IMAGES of America
MONTROSE

ON THE COVER: Citizens of Montrose turned out in large numbers to attend a parade celebrating the most important event in local history. The president of the United States, William Howard Taft, was visiting to open the Gunnison Tunnel. The Uncompahgre Project, one of the first projects undertaken by the newly created US Bureau of Reclamation, had required nearly five years and millions of dollars to bring more water into the valley. (Courtesy of the Montrose County Historical Society & Museum.)

Montrose County Historical Society & Museum

Copyright © 2017 by Montrose County Historical Society & Museum
ISBN 978-1-4671-1637-4

Published by Arcadia Publishing
Charleston, South Carolina

Printed in the United States of America

Library of Congress Control Number: 2016956743

For all general information, please contact Arcadia Publishing:
Telephone 843-853-2070
Fax 843-853-0044
E-mail sales@arcadiapublishing.com
For customer service and orders:
Toll-Free 1-888-313-2665

Visit us on the Internet at www.arcadiapublishing.com

This work is dedicated to area pioneers, past and present, and to the generous supporters of the Montrose County Historical Society & Museum striving to preserve, protect, and interpret the historical and cultural legacy of Montrose County.

Contents

Acknowledgments		6
Introduction		7
1.	Uncompahgre Valley Early Days	9
2.	The Railroad Arrives	21
3.	Founders and Farmers	33
4.	Liquid Treasure	45
5.	Agriculture Expands	63
6.	A Community Develops	87
Bibliography		127

Acknowledgments

All the images used in this work come from the Montrose County Historical Society & Museum's photographic collection. However, that collection would not exist if many community members, both past and present, had not so generously donated their cherished and unique photographs to the museum so they could be preserved as an authentic record of the community's past. For those acts of altruism and goodwill, the society is most grateful.

INTRODUCTION

Montrose is located midway on Colorado's western slope, at an elevation of 5,806 feet, in the valley of the Uncompahgre (un-cum-PAH-gray) River, about 65 miles east of the Colorado-Utah border. Rimmed to the south by the heavily mineralized 14,000-foot peaks of the San Juan Mountains and to the west by a 10,000-foot plateau, location has always played a major role in Montrose history.

As the historic homeland of the seminomadic Ute Indians, western Colorado was a mountain sanctuary ideally suited to their hunter-gatherer lifestyle. An 1868 treaty granted western Colorado to the Utes, promising to honor their territory "for as long as the grass grows and the rivers run." Two agencies were established, one on the White River and one on Cochetopa (ko-che-TOE-pu) Pass. By 1872, gold and silver strikes in the San Juans had caused prospectors and settlers to pour onto Ute land. The US government sent Indian commissioner Felix Brunot to induce the Utes to give up the San Juans.

The treaty of 1874, also known as the Brunot Treaty, removed four million acres in the San Juans. Thousands of miners and settlers poured onto the newly available land. Gold-seekers dug holes, stripped timber, spoiled water, and killed Ute livestock. Trespassing became serious enough that federal troops were sent in twice to remove intruders. General anxiety provided fuel for Colorado politicians and anti-Ute newspapers to press for removal.

An armed confrontation between the White River Utes and Indian agent Nathan Meeker provided the federal government with the necessary pretext. Yet another treaty was presented. With the death of Chief Ouray, distrustful Utes refused to sign the treaty, so interpreter Otto Mears paid $2 for each Ute signature mark on the treaty. Mears was later reimbursed from the federal treasury.

Troops under Col. S.R. Mackenzie were ordered to the Uncompahgre Valley to establish a military post, known as the Cantonment on the Uncompahgre, and to direct the removal of the Utes. Five companies of men spent the winter of 1881 in the tents of a temporary camp while they were engaged in the construction of a new military post. The following summer, reluctant Utes gradually prepared for removal. On September 7, 1881, the last band of western Colorado Utes left their homeland. In June 1882, the federal government opened six million acres of former Ute land to homestead settlement, but there had been so many encroachments that settlers had difficulty finding unclaimed sites.

At the same time, the Denver & Rio Grande (D&RG) narrow-gauge railroad was building the first rail system through the Rocky Mountains, to connect Denver and Salt Lake City. Use of the narrow-gauge system permitted the creation of sharper curves, an important consideration in the rugged Rocky Mountains. Railroad construction through the Black Canyon proved to be much more difficult than had been expected. Early stages of construction required workmen to be lowered down the steep canyon sides by ropes, from which they hung to drill holes for blasting out footholds to carve a roadbed. A year later, and 15 difficult miles farther west, the railroad was forced to leave the canyon at Cimarron. By September 8, 1882, the D&RG had climbed the four-percent grade over Cerro Summit and followed Cedar Creek to the Uncompahgre River, the location of present-day Montrose. Today's Montrose grew from that humble beginning to become the regional hub of western Colorado.

One
Uncompahgre Valley Early Days

With the western movement of settlers, the indigenous residents of Colorado, the Ute Indians, came to be viewed as obstructions to Anglo-American prosperity. A treaty to reduce competition and confrontation was seen as the solution and a response to growing political pressures. Loosely divided into seven bands, the Utes had never been a unified group, so the US government selected a spokesman to serve as "chief" of the Ute Nation and represent all Utes in treaty negotiations.

Their choice fell on 35-year-old Ouray, of half Ute and half Jicarilla Apache ancestry and raised in Spanish-speaking Taos, New Mexico. Having a trace of formal education from Catholic friars, Ouray could converse in Ute and Spanish, with a smattering of English. Also of importance, though not officially recognized, was Ouray's witnessing of the US military's previous extreme action against the Navahos and Apaches in 1863.

The 1868 Ute solution was a treaty that granted them "title" to 40 percent of their traditional domain "for as long as the grass grows and the rivers run." In addition, the treaty promised yearly annuities of clothing, blankets, and food, cattle and sheep herds, and protection from encroachments onto the reservation. For both sides, promises proved to be insufficient.

Even the use of military enforcements failed to convince gold and silver prospectors to respect reservation boundaries. Colorado newspapers and politicians were outspoken in their disapproval of any and all access restrictions. With yet another treaty in 1873, the Utes ceded the mineral-rich San Juan Mountains.

The Los Pintos Agency moved to the Uncompahgre Valley in 1875 for a short five-year period before an armed confrontation at the White River Agency resulted in another treaty. The 1880 treaty removed the majority of Ute Indians from the state of Colorado.

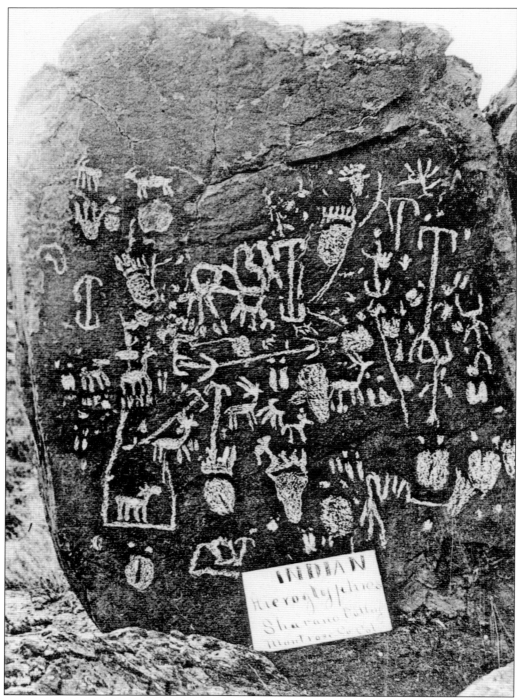

Ancient residents in the Uncompahgre Valley left a record of their presence through messages chipped into multiple local rock faces. What those messages say, to whom or what they are addressed, and exactly how old they are, is not known. Modern Ute Indians are able to interpret some of the markings, while other symbols remain a mystery.

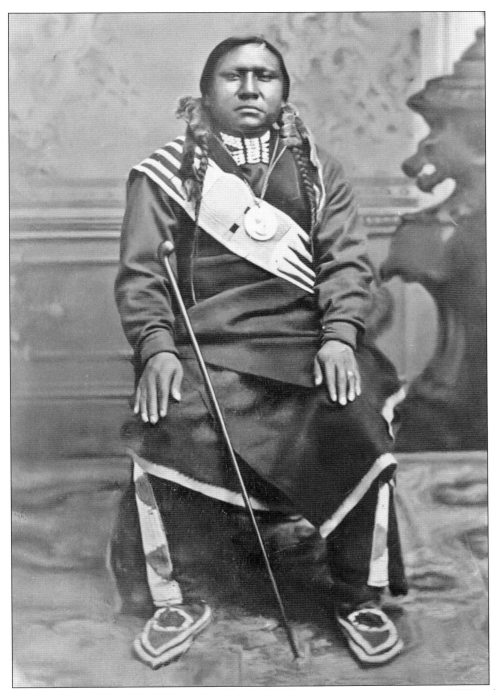

Born in New Mexico in 1833, Ouray was selected by US government negotiators in 1863 to be the spokesman, or "chief," of the multiple, fragmented Ute bands. He was fluent in Spanish and could understand and speak some English. Negotiations resulted in the 1868 treaty that granted western Colorado to the Utes, promised to prevent incursions onto Ute land, and established two agencies to supply annual disbursements of livestock and rations.

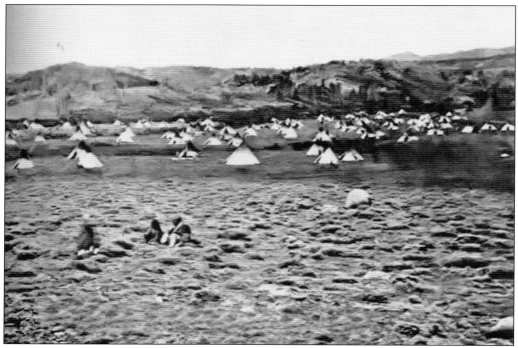

Movement from the San Luis Valley took Ouray's people to Los Pintos Creek and an agency on the 10,032-foot Cochetopa Pass. The mountainous location made supplying the agency difficult, and bitter-cold winters made living at the agency demanding. Several other locations were considered before it was decided to move to the valley of the Uncompahgre River.

Moving everything to the new Los Pinos Agency, located 12 miles south of present-day Montrose, through 70-plus miles of rugged terrain with no roads, required weeks of struggle. Transporting all the agency equipment and 1,200 head of government livestock proved especially difficult. New structures were erected to replace agency buildings that had been abandoned in the move.

Ouray continued to serve as the recognized Ute spokesman. He neither smoked nor drank alcohol, shielding him from the influence of unscrupulous traders. Serving as a buffer between the federal government and the disorganized and often resentful Utes, Ouray attempted to serve as mediator. While he recognized armed Ute resistance to white intrusion was doomed to failure and treaty promises were fated for miscarriage, Ouray struggled for calm and peace on both sides.

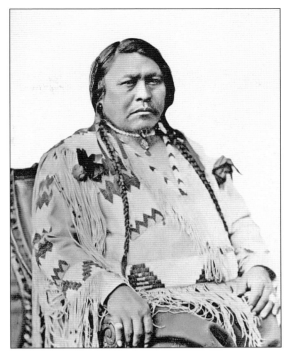

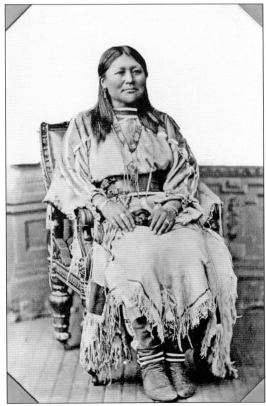

Born in New Mexico in 1843, a member of the Tabeguache (tab-a-watch) band, Chipeta, married Ouray in 1859. Acting in support of her husband, Chipeta was accepted at council meetings and, rare for a Ute woman, joined in his efforts to negotiate treaties for their people. She accompanied Ouray to Washington, served as his adviser, and testified at some of the hearings.

Ouray was 26 and his second wife, Chipeta, was 16 when they were married in 1859. They were very devoted to each other. Following the death of Ouray, Chipeta gave up her government-built house and returned to living her life in a more traditional manner. She died on the reservation in Utah in 1942. The following year, her remains were reburied on the grounds of her old home near Montrose.

As a result of rich strikes in the San Juan Mountains, gold and silver prospectors poured onto the reservation. In spite of the efforts of government troops, it proved impossible to stop trespassers. US commissioner Felix Brunot, Indian agent Charles Adams, and interpreter Otto Mears persuaded the Utes to give up the mountainous land in another treaty. While the Brunot Treaty separated another four million acres from the Ute reservation, it failed to provide a solution to growing hostilities. Early settlers and prospectors continued to trespass on Ute land, and the Indians continued to roam their historic hunting grounds.

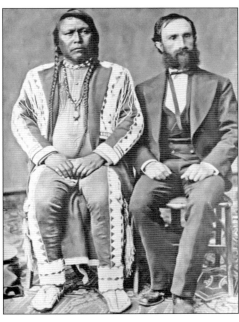

Following an armed confrontation with the Northern Utes at the White River Agency in 1879, pressure increased to remove all Utes from Colorado. Newspaper headlines screamed, "The Utes Must Go," and an opportunity to acquire valuable Indian land beckoned speculators. A seriously ill Ouray headed yet another treaty delegation to Washington. By this treaty's terms, the Northern and the Uncompahgre Utes were to be moved to new reservations. Before the treaty was accepted, Ouray died of Bright's disease on August 24, 1880. After Ouray's death, in order to acquire approval of the treaty by three-fourths of the Utes, Otto Mears paid $2 for each Ute signature.

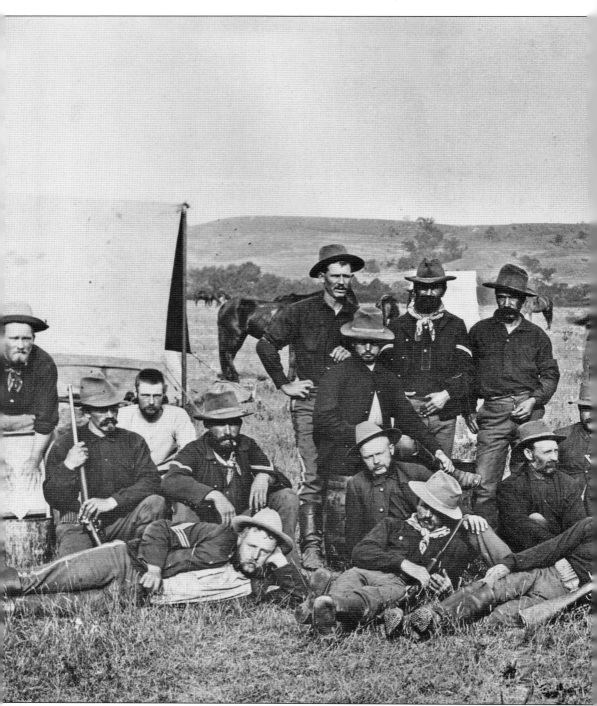

Tasked with peacekeeping and preventing any uprising from the Uncompahgre Utes, the Cantonment on the Uncompahgre, a military supply camp, was established four miles north of the Uncompahgre Ute Indian Agency in May 1880. Intended as a temporary assignment, the troopers at the camp lived in tents and ate food prepared in the open. In August 1880, the

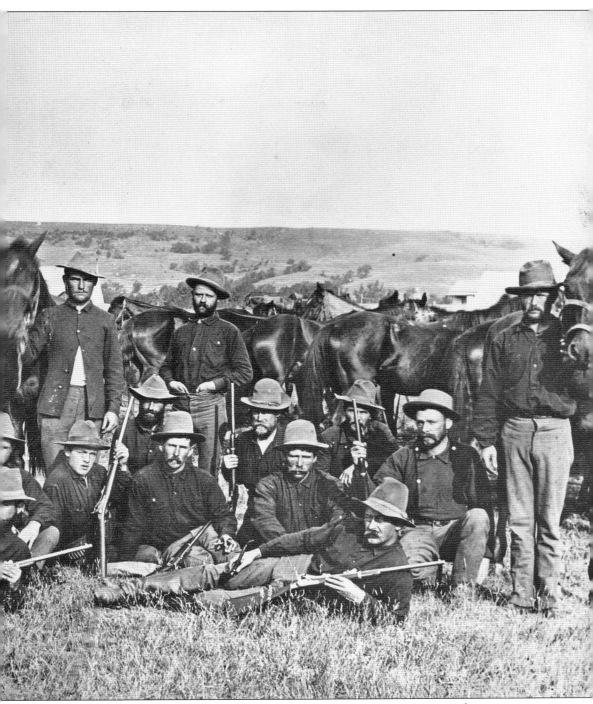

command of Maj. Joshua S. Fletcher Jr. was directed to construct a new post at the cantonment. That winter, the men were still living in tents and suffered much from the cold. Despite having Sibley stoves to warm the tents, the morning light would find their beds covered with snow.

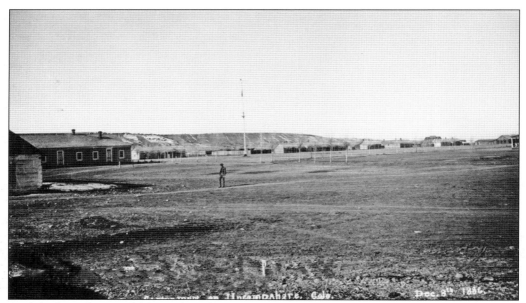

With little timber available in the valley, logs had to be cut and hauled from the forests to the south so lumber could be sawed into pickets and boards at the site. Buildings of both frame and picket-style construction were built as quickly as possible, with more permanent quarters in use by summer.

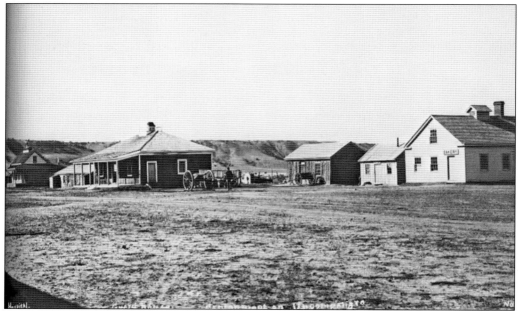

The buildings at the cantonment became permanent structures devoted to specific functions. Gradually, civilians moved in to provide various services, such as laundering, baking, blacksmithing, and tending the cattle herd. With families of the men also living on-site, the cantonment population increased to resemble a small community.

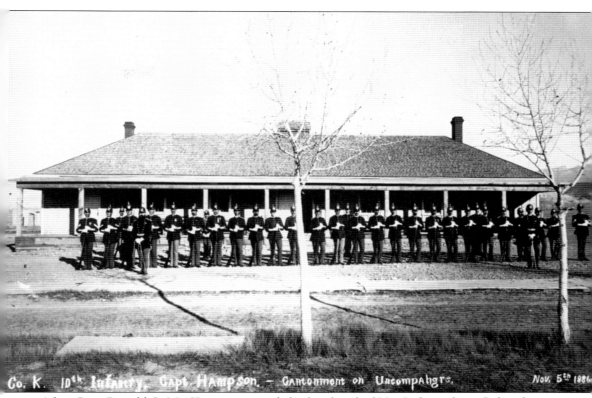

Co. K. 10th Infantry, Capt. Hampson. – Cantonment on Uncompahgre. Nov. 5th 1886

After Gen. Ranald S. MacKenzie removed the last band of Ute Indians from Colorado on September 1, 1881, the troops at the cantonment settled down to routine garrison duty. In 1886, the Cantonment on the Uncompahgre was renamed Fort Crawford in honor of Capt. Emmet Crawford, who was killed in Mexico.

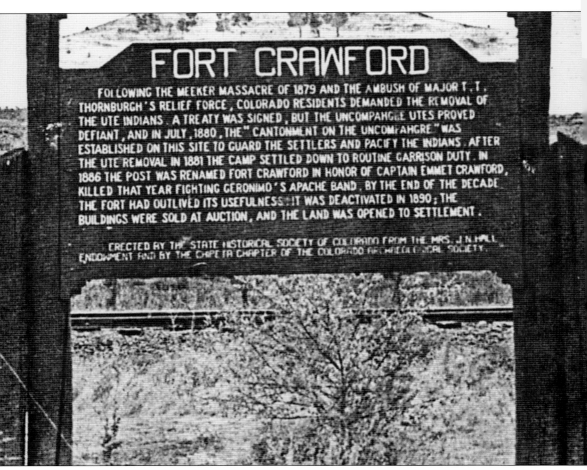

When the Army recognized the military purpose of Fort Crawford had been fulfilled and began to talk of closing it, Montrose merchants strongly objected to losing such dependable clientele. Claiming a need for "protection" should the Utes return, Montrose citizens were able to convince the Army to maintain the fort for a few more years. By 1890 that argument was no longer effective, and the fort was deactivated that year.

Two

THE RAILROAD ARRIVES

The dust had scarcely settled after the removal of the Utes from the Uncompahgre Valley when the Denver & Rio Grande (D&RG) narrow-gauge railroad arrived. William Jackson Palmer was realizing his determination to reach the booming gold and silver mines with a railroad that would connect Denver and Salt Lake City. His goal was clearly stated in a company brochure: "We go through the mountains not around them." While steep mountain passes and narrow canyons made standard four-foot, eight-and-a-half-inch rail widths too costly, a narrow-gauge three-foot track could make sharper curves and required less roadbed preparation.

Leaving Denver, the D&RG ran south to Pueblo, then turned west toward the Continental Divide. After purchasing the Otto Mears Toll Road over Marshal Pass, the "Baby Road" zigzagged back and forth through canyons and around hillsides to gain the summit. To climb from an elevation of 7,000 feet to 10,858 feet in 25 miles, with an average grade of 3.5 percent and an equally steep and meandering descent, up to three engines were required to move loaded freight trains.

Arriving in Gunnison on August 8, 1881, the D&RG continued work on the main line toward Montrose while a second line was quickly laid to tap Crested Butte coal mines. Access to some of the best locomotive coal in the West would prove a welcome financial benefit as the Black Canyon of the Gunnison began to consume time, money, and men.

Surveying crews had been working the route west of Gunnison from as early as the previous April. Intending to build the line through the canyon to the intersection with the Uncompahgre, surveyors were unable to penetrate the canyon any farther than the confluence of the Cimarron. Surveying from boats anchored by ropes or drilling rock walls by hanging from the canyon rim were just samples of the difficulties to come. The 15-mile roadbed from Sapinero to Cimarron took over a year to build and cost a staggering $165,000 per mile.

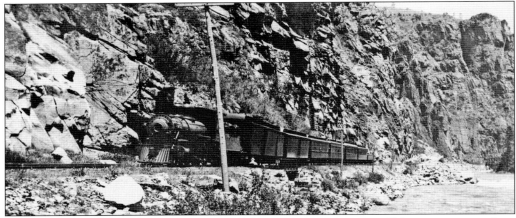

Roadbed construction in the narrow gorge of the Black Canyon required blasting a passage from the granite walls and placing the rubble along the river edge. Ties and track laid on the packed rubble created a road for train travel. The completed grading had to be built high enough to keep the road above the river at flood stage. Work in the canyon was costly, both in time and in men. A new explosive called nitroglycerine killed and injured some workmen, while others drowned in the river or were crushed by falling rocks.

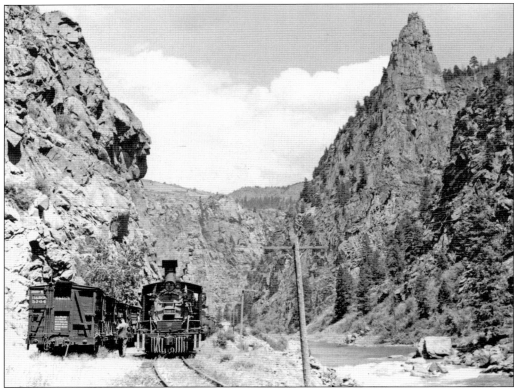

A rare wide spot in the Black Canyon allowed sufficient space to be carved out to hold a siding. Old freight cars were equipped to provide living quarters for workmen. Outfitted with plank tables and benches for meals or with narrow board bunks for sleeping quarters, these "hotels on wheels" could be parked on the siding.

Across the river from the 1,000-foot-plus formation called Curecanti Needle, the D&RG established a small section house. While initially serving railroad functions, Curecanti also became a destination. Both local sportsmen and railroad guests would ride the train to this stopping point, then fly-fish the world-renowned waters of the Gunnison River.

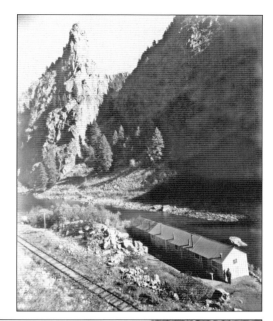

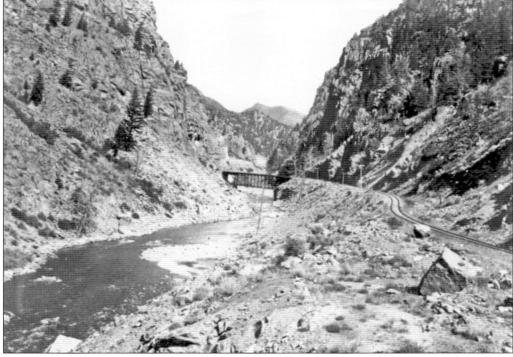

Accepting the surveyor reports that further penetration of the Black Canyon would be impossible, the route turned up the Cimarron River tributary. Exiting the canyon, the railroad followed the standard practice of establishing a new townsite at the railhead, located on the ranch of W.M. Cline. Out of the dark, cold canyon, Cimarron was a welcome relief; it had taken a year to complete the 15 miles from Sapinero. Now, the 450 men prepared to push the tracks west over the 8,660-foot Cerro Summit.

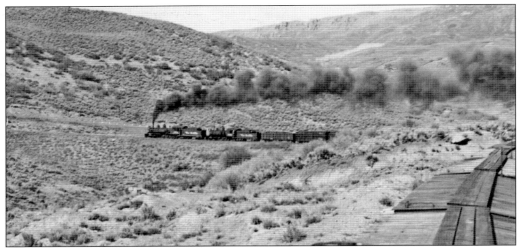

Between Cimarron and Gunnison, the line traveled on a minimal grade, and little additional power was required, but both sides of the 8,660-foot Cerro Summit were a steady four-percent grade. Helper engines were necessary for 14 miles on both sides of Cerro from Cimarron to Cedar Creek.

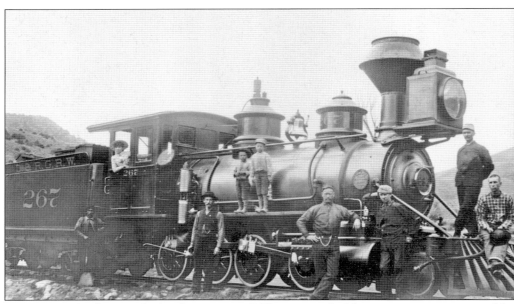

Engine No. 267, photographed at Cimarron in 1885, was typical of the narrow-gauge engines of the time. The extra-long spout on the oilcan held by the man at center gave employees the necessary reach to lubricate any moving part. The railroad shops at Cimarron provided maintenance for any rolling stock passing through the area. The Cero Summit helper engines were stationed here, and railroad employees lived in the growing community.

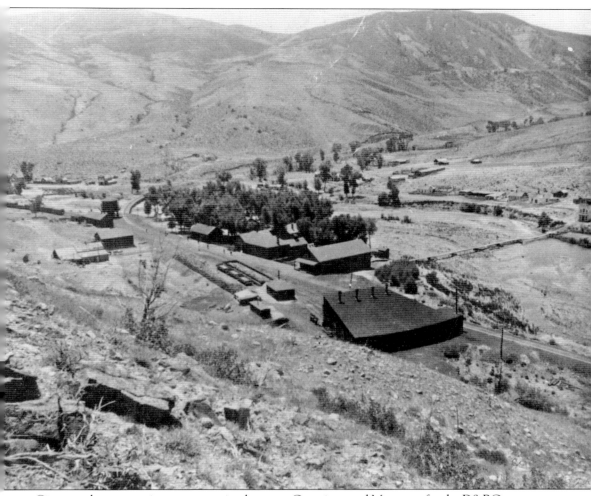

Cimarron became an important station between Gunnison and Montrose for the D&RG narrow-gauge railroad. Here, the line emerged from the scenic but dangerous Black Canyon and made preparations for the climb up the four-percent grade of Cero Summit. A regular 20-minute stop was scheduled to add the helper engines to the train and to allow passengers to get a hot meal at the Black Canyon Eating House.

The lunchroom serving train passengers in Cimarron was called the Black Canyon Eating House. Employee dress was inspired by the Fred Harvey lunchrooms that served passengers on the Atchison, Topeka & Santa Fe. While not reaching that level of service, the lunchroom served standard fare that was popular with both locals and train patrons. Served family style, meals were prepared for 24 railroad men daily, with an increase during stock shipping time.

On September 8, 1882, a month after leaving Cimarron, tracklayers completed the 24 miles to reach the new townsite of Montrose. The railroad was not willing to establish a depot where the town was already located. The first Montrose depot was placed in a more isolated area north of the established townsite. However, because land for a town had already been located, the railroad did not attempt to establish a railroad-controlled settlement.

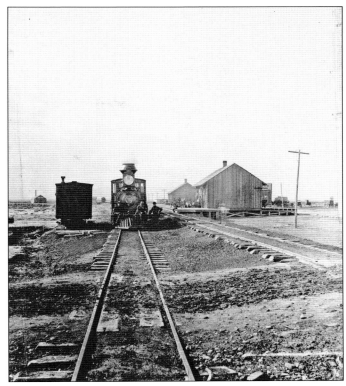

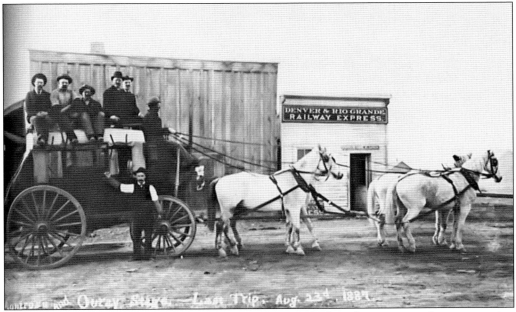

For five years after the D&RG reached Montrose, passengers had to rely on stagecoach transportation for travel to Ouray and other mining towns. The stage left Montrose every morning, and a return stage arrived in Montrose each evening. After Otto Mears built the Rio Grande Southern, the final stage run from Montrose took place on August 23, 1887.

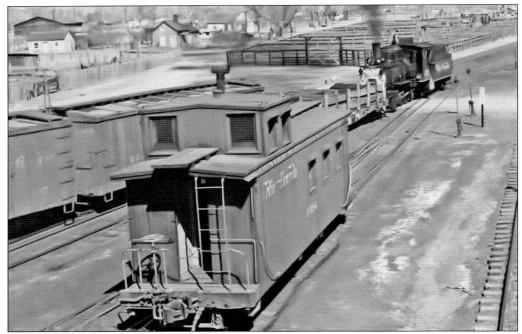

Rail transportation of gold and silver ore from the San Juan Mountains and shipments of inbound freight for the mining communities provided the initial support for the growth of Montrose. Soon, livestock pens were built near the rail yards to accommodate the transportation of sheep and cattle to distant markets or to seasonal grazing locations. Provided with water and feeding facilities, the pens saw heavy use every spring and fall.

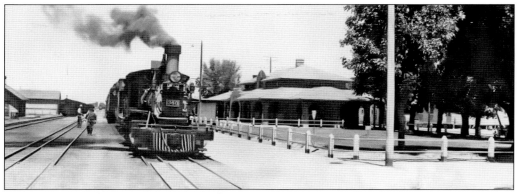

In 1906, the line between Montrose and Grand Junction was adapted to the larger and heavier standard gauge. To accommodate both gauges, a third rail was laid alongside the narrow-gauge track. Traffic could travel between Grand Junction and Montrose on the standard-gauge rails, then change to the narrow-gauge line to make the run east through the Black Canyon and over Marshal Pass.

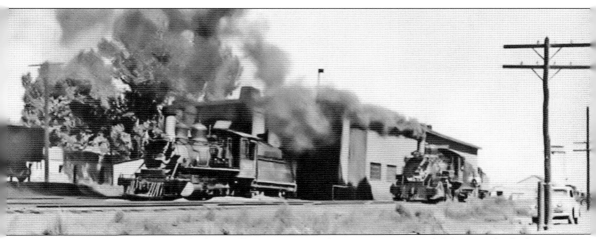

Montrose did not have a standard roundhouse to service locomotives. Instead, Montrose had what was called an engine house because it did not contain a turntable to rotate engines. Located south of busy street crossings, the structure's purpose was the same, with train engines being serviced and stored on a temporary basis within the shelter of the building.

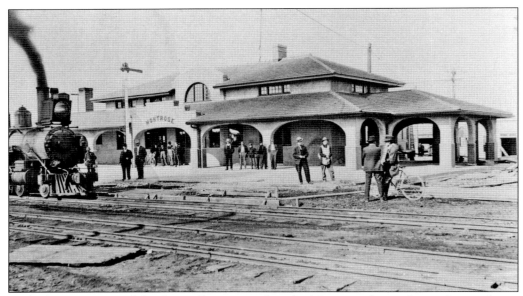

As both passenger and freight traffic increased at the Montrose depot, demands were being voiced for a new and improved facility. The local newspapers joined community businessmen in the campaign to persuade the railroad to do something about the old frame depot building. In 1912, the D&RG Western let a contract to build a new depot to serve the people of Montrose. Listed in the National Register of Historic Places in 1982, that building now houses the Montrose County Historical Society & Museum.

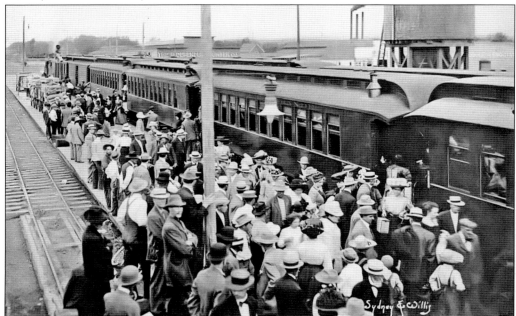

With the ongoing introduction of new amenities, the residents of Montrose embraced train travel. The depot platform filled with travelers when a train came in, as citizens and tourists alike prepared for the next segment of their journey. Travel by rail, for both business and pleasure, boosted the Montrose economy and encouraged community growth.

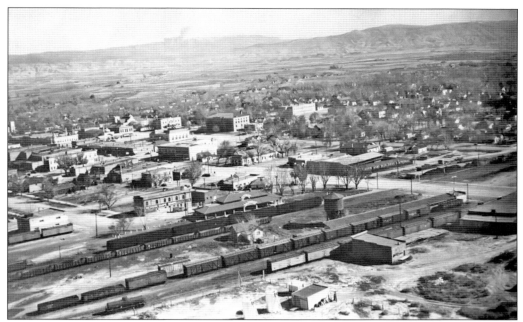

With the railroad at its core, Montrose had grown to be the agricultural market center of west-central Colorado by the 1930s, filling a productive, stable role in the health of the community. The Depression years and another world war was yet to reach Montrose. How could the citizens of Montrose have dreamed of the dark years just around the corner?

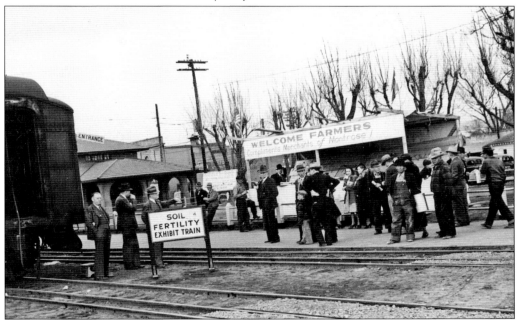

The 1940s saw visits to Montrose from special-purpose trains sponsored by the US Department of Agriculture. The federal government sponsored these traveling educational programs with the intent of educating farmers about soils, crops, and conservation practices. The special railcar would be parked on a side track for a week or so to assure everyone had an opportunity to visit.

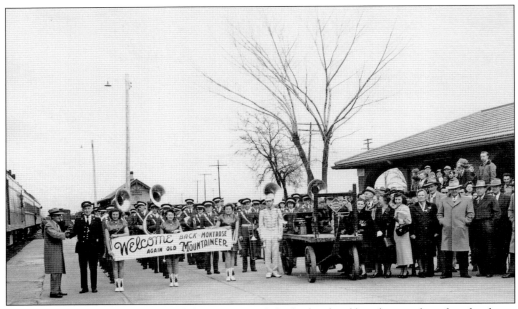

It is a mystery as to why these local dignitaries and the high school band are gathered at the depot with a sign that reads, "Welcome back again old Montrose Mountaineer." The Mountaineer was the passenger service from Montrose to Denver by way of Grand Junction that ended in 1959. There is no record of the Mountaineer having left before 1959 or of it ever returning to Montrose.

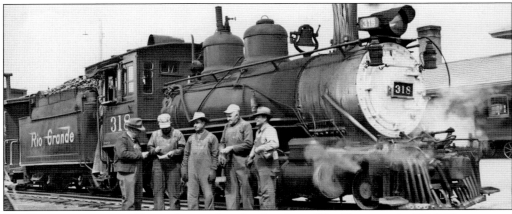

The Depression years and beyond saw reduced railroad use. The Shavano, the D&RG's passenger service to Gunnison and points east, stopped running in 1940. Freight service to Gunnison was reduced, then discontinued, with the rails removed in 1949. Engine No. 318 made its last scheduled trip from Montrose to Ouray on March 21, 1953.

Three

FOUNDERS AND FARMERS

With word that the Utes would be removed from western Colorado, eager immigrants began searching for a locale to settle. While some had been living on Indian land with permission, others had encroached in spite of the military's efforts. Once the Utes were gone, the rush began. The government did not complete a survey until 1883, so settlers staked out tracts to suit their own taste or a neighboring boundary. Later surveys led to much confusion, dissension, and resentment.

O.D. Loutsenhizer, Joseph Selig, John Baird, S.A. Culbertson, and A. Pumphrey staked out a townsite where the D&RG Railroad was expected to locate a depot. J.C. Frees built the first store on the corner of Cascade Avenue and present-day Seventh Street. Other merchants and professional offices followed, but the D&RG did not cooperate. The depot was placed half a mile northwest on Second Street, now known as North First Street. The town company offered choice new sites on present-day Main Street to any business willing to relocate. Buildings were hastily placed on skids and moved to the new location by teams of mules or oxen.

Although early-day saloons outnumbered any other type of business establishment, they were soon crowded out by more legitimate enterprises. The newspapers began to arrive, followed by freighting companies, merchants, and other businesses. By 1912, Montrose had become home to three newspapers at the same time.

Montrose's position as a distribution point for the outlying mining districts was an important factor in the growth of the town. Several freighting companies established headquarters in Montrose to transport goods from the railroad to sites in the distant, rugged San Juan Mountains.

Outlying farms and ranches increased, with Montrose as both a supply center and an outlet for agricultural products. Shipping produce by rail expanded the markets available to producers. The population of the community increased, and directing the city's development became the focus of the citizenry.

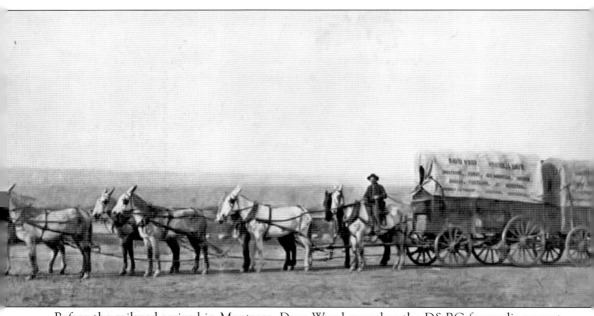

Before the railroad arrived in Montrose, Dave Wood served as the D&RG forwarding agent, transporting freight to locations the railroad could not serve. After 1882, he operated from headquarters near the depot, shipping to and from the San Juan mining locations. He built the Dave Wood Road, from Montrose to Leopard Creek, to reduce problems presented by the Otto Mears Toll Road over Dallas Divide.

O.D. Loutsenhizer, known as "Lot," first visited the area in 1873 with an ill-fated party of gold-seekers guided by Alferd Packer. Seeking a ranch location, Loutsenhizer later returned to the Uncompahgre. When Joseph Selig arrived, Lot joined him in locating a townsite, becoming one of Montrose's founders, along with W.A. Eckerly, John Baird, A. Pumphery, and T.H. Culbertson. Lot's farm became the Loutsenhizer Addition to the city of Montrose.

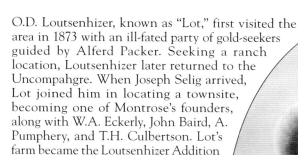

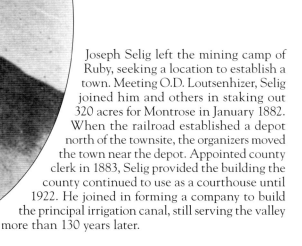

Joseph Selig left the mining camp of Ruby, seeking a location to establish a town. Meeting O.D. Loutsenhizer, Selig joined him and others in staking out 320 acres for Montrose in January 1882. When the railroad established a depot north of the townsite, the organizers moved the town near the depot. Appointed county clerk in 1883, Selig provided the building the county continued to use as a courthouse until 1922. He joined in forming a company to build the principal irrigation canal, still serving the valley more than 130 years later.

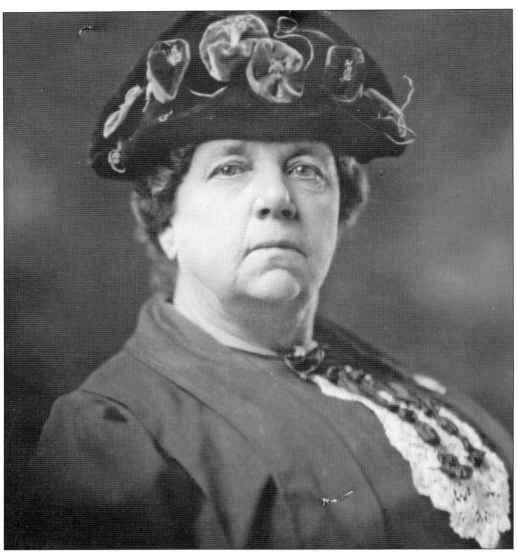

James A. Fenlon was transferred to Fort Crawford in 1880 to serve as the civilian employee in charge of the trader's store serving the Uncompahgre agency. In 1882, he married Elizabeth "Lizzie" Bowen Clarke, and they lived near the agency, operating a store and stage stop. The Fenlons filed on the abandoned Fort Crawford property and developed it into a well-irrigated farm. Upon the death of James, Lizzie proved to be a resourceful manager of their several holdings. In 1928, she purchased and donated the residence for the Episcopal Church rectory.

In 1882, J.C. Frees opened the first store in Montrose at the original townsite, moving with the town to the corner of Uncompahgre Avenue and Third (later Main) Street. By 1884, he had expanded into a large general supply store. In 1905, he built the two-story brick building now occupying 447 East Main Street. In 1889, Frees joined in organizing the First National Bank, serving as a stockholder and director.

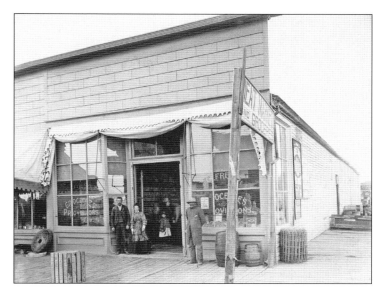

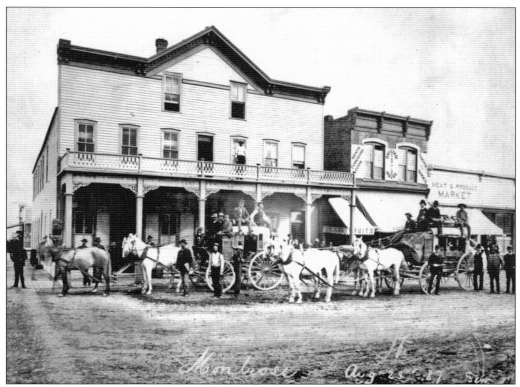

Otto Mears joined the Main Street construction by building a two-story frame hotel on the corner of Main Street and Cascade Avenue. The top floor was separated into rooms by hanging sheets of canvas, while the first floor was devoted to a bar and gambling tables. The J.C. Sanderson Company operated from the hotel, running daily four-horse stagecoaches to Ouray, Telluride, and Gunnison.

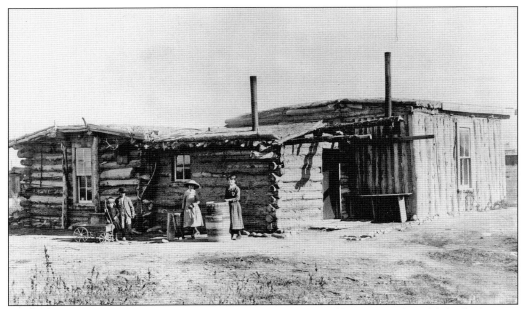

Evan and Alvilda Willerup came to the Montrose area in the fall of 1881 and established a farm on the east side of the Uncompahgre River. The home, constructed of available materials and built in a manner common at the time, has been mistakenly identified as the first residence in Montrose. The farm was later divided into city lots and became known as the Willerup addition.

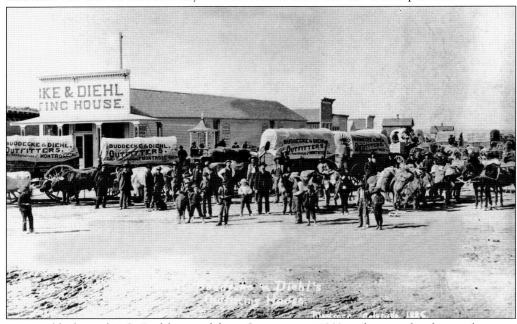

A.E. Buddecke and R.C. Diehl arrived from Gunnison in 1882 with a couple of six-mule teams and wagons stocked with dry goods and general merchandise. Their first store in Old Town Montrose was constructed of logs. They established a freighting company and placed the combined businesses at the corner of Main Street and Cascade Avenue. Supplies were transported to the San Juan mining camps with both ox and mule teams.

Hugo Selig, nephew of town founder Joseph Selig, came to Montrose in 1887 and established a law practice. He served as deputy district attorney from 1890 to 1898 under John Gray, becoming district attorney in 1905. He prosecuted numerous cases arising from the Western Federation of Miners strikes of 1905–1906. His book *Early Recollections* is one of the few first-person records of early Montrose history.

John Gray came to Montrose from Silverton in 1884 and opened a law office. Active in both civil and legal fields, he served terms as Montrose mayor, county and city attorney, county judge, and district judge. Also active in water litigation, Gray drafted the bill presented by Mead Hammond to appropriate funds for the state tunnel. An avid supporter of the arts, Judge Gray built an opera house on North First Street for daughters Anna, Mary Olive, and Theodosia to have a performance site.

F.J. "Joe" Hartman joined his brother S.C. "Sid" Hartman in opening a bicycle repair shop in 1904. In 1908, the Hartman brothers were appointed a dealership for Ford Motors. They changed their agency to a Dodge dealership in 1916. The Hartman family continued that association until leaving the automotive business and going into a medical supply service in 1999.

John C. Bell opened a Montrose law practice in 1885 after arriving from Lake City, Colorado, where he had prosecuted the notorious Alferd Packer. Bell served as county court judge and as judge of the Seventh Judicial District (1888–1893), then was elected to five terms in the US House of Representatives (1893–1903). Bell supported water projects and the passage of the 1902 US Reclamation Act, helping secure the Uncompahgre Project. He was selected as the Uncompahgre Water Users Association's first president.

William O. Redding came to Montrose in 1888 and quickly became involved in community affairs. He owned a furniture store in Montrose, as well as a real estate and insurance company, and later bought the Redding Abstract Company. Redding served terms as president of the Montrose Chamber of Commerce and as treasurer of School District No. 1. He then served as mayor of Montrose in 1897 and helped create its city manager form of government in 1914.

Dr. Harriette Collins came to Montrose from the rough mining camp of Victor. She set up a medical practice around 1902, becoming Montrose's first female doctor. Dr. Collins had the distinction of owning one of the first X-ray machines in western Colorado. As a charter member of the Montrose Medical Society, she served as its secretary. Marrying William Lingham, she gave up her practice in 1906 but continued to reside in Montrose.

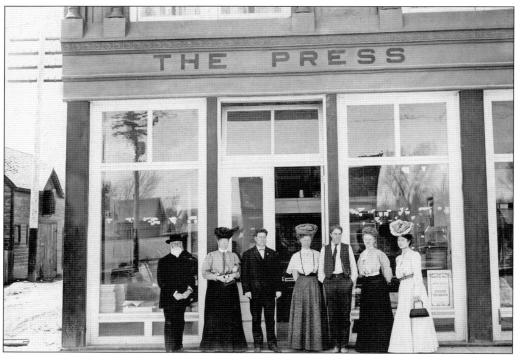

Charles E. Adams came to Montrose in 1904 and bought a weekly newspaper, the *Montrose Press*. In 1908, he started a daily paper, the *Montrose Daily Press*, and began decades of community contributions. In addition to serving with the chamber of commerce, four lodges, the Rotary Club, and a relief committee during the Depression, Adams promoted the construction of a new Montrose High School. He was also instrumental in influencing the improvement of US Highway 50 from Pueblo to Utah.

Al A. Neal came to Montrose County in 1884 and became actively involved in the livestock business on an extensive scale. He served as president of the Cattle and Horse Show Association of the Uncompahgre Valley and later of the Uncompahgre Cattle and Horse Growers Association. On several occasions, his cattle were judged award winners at the International Stock Show in Chicago.

Attorney Charles J. Moynihan came to Montrose from Lake City, Colorado, to join the law firm of Sterling Sherman. In 1913, he served on the committee that fashioned Montrose's home-rule charter and was appointed the first mayor of Montrose. In 1925, as a member of the Colorado Board of Corrections, he started the first major road construction over Cero Summit, using convict labor.

John Tobin came to Montrose with his brother Bernard in 1884. John became the first principal of Central School, then was elected county superintendent of schools. He was one of the organizers of the Montrose Driving Park Association, which purchased the real estate that would become the Montrose County Fairgrounds. The site was sold to Montrose County in 1919, with deed restrictions to always be used for fair purposes and to remain alcohol free.

Walter Lacher was employed first at the First National Bank, then moved to work for the Redding Abstract Company. In 1906, he married Miss Nellie Frees, daughter of J.C. Frees. When his father-in-law purchased the Montrose Abstract Company in 1910, Lacher assumed the management position. He remained for many years, overseeing legal property registrations.

Trained nurses Anna D. and Allen Fender purchased a large 11-room house from George Gilbert in 1917. The home, located at 130 South Cascade Avenue at the intersection of South Second Street, was converted into St. Luke's Hospital. By the following year, Allen had died during the influenza epidemic, but Anna carried on, operating St. Luke's until 1950. Named Woman of the Year in 1947, she was believed to have delivered more than 5,000 babies. The nursery at Montrose Memorial Hospital was named for her.

Four

Liquid Treasure

The Ute removal opened western Colorado to settlement, and soon, numerous irrigation efforts were attempted to provide water to the virgin farmland. It quickly became apparent that the Uncompahgre River was overcommitted and inadequate to supply sufficient water for the latter part of the growing season. Crops dried up and died during hot summer months. Many relief schemes were proposed, but without success.

F.C. Lauzon called for the construction of a tunnel from the Gunnison River to the Uncompahgre Valley. Understanding such a project was beyond local capabilities, Mead Hammond shepherded a bill through the 1901 Colorado state legislature to provide $25,000 for starting work on this tunnel. A second exploration attempt, to find an inlet location in the Black Canyon, was successful in 1901. In November, work began on State Tunnel No. 3. The following year, after progressing 900 feet, the money ran out, and lack of funds forced abandonment.

The US Reclamation Act, promoted by legislators from arid western states and backed by Pres. Theodore Roosevelt, became law in 1902. The Uncompahgre Project was selected and placed on the list of five initial federal projects. Work on a new tunnel began in January 1905.

Construction of a tunnel to tap Gunnison River water was difficult from the beginning. The River Portal could only be reached by means of a dangerous wagon road with up to a 30 percent grade in places. Headquarters were located at the portal opening on the Uncompahgre end where the construction community of Lujane (Lu-wan) was sited. A ventilation shaft was drilled midway, and two more faces were worked from this additional location. At the same time, the South Canal was constructed to carry the water from the tunnel to the Uncompahgre River to be distributed through the canals and ditch system.

Completed in 1909 at a cost of $2,905,307 and reaching 30,650 feet (5.8 miles), it was the longest irrigation tunnel in the world. Pres. William Howard Taft attended the dedication ceremonies as guest of honor and primary speaker. Carrying 1,000 cubic feet per second, the tunnel continues to transmit a liquid treasure to the Uncompahgre Valley to support today's population.

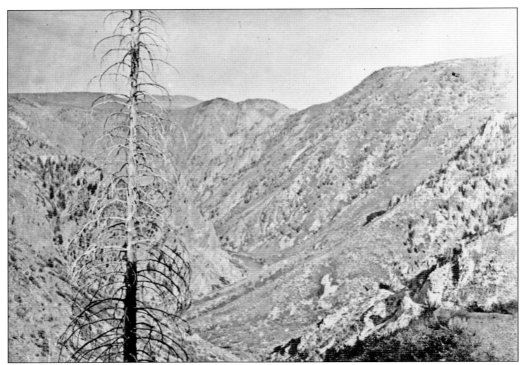

The Gunnison River drops 2,150 feet through the Black Canyon, an average of 43 feet per mile. For comparison, the drop of the Colorado River in the Grand Canyon averages 7 feet per mile. The canyon reaches a depth of 2,700 feet and reduces to 1,500 feet wide at the Narrows. The sun shines directly on the river during only a few hours at midday, thus the name Black Canyon.

Francoise Lauzon conceived the idea of tapping the Gunnison River with a tunnel to acquire more water for the valley farmers. Unable to raise enough money locally, he successfully rallied the citizens in pushing for state funding of a tunnel. The State of Colorado appropriated $25,000 to make a survey and begin work on State Tunnel No. 3. A location was selected and work began, but the allocation was quickly consumed and work halted.

Following passage of the National Irrigation Act in 1902, the newly created Reclamation Service was convinced to investigate the possibility of an irrigation tunnel. William A. Torrence, superintendent of the Montrose Electric Light and Power Company, joined USGS surveyor A. Lincoln Fellows in a second attempt to explore the canyon and determine tunnel feasibility. They were to conduct a survey, map the area, and report on the geology to identify a potential tunnel location.

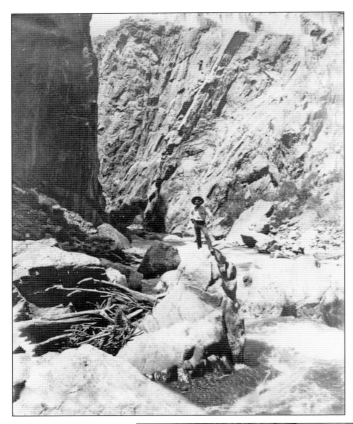

Equipped with a rubber boat to transport provisions, Fellows and Torrence had hopes of overcoming the rugged conditions that had forced abandonment on previous exploration attempts. The men found the Gunnison River canyon to be so narrow that many spots had no riverbank upon which to base tunnel construction. Steep walls of granite funneled the river through narrow chutes and around boulders as large as a small house.

The surveying equipment and supplies were placed on rubber rafts and floated down the river. In places where there was no way forward but to swim the river, one man would hold the end of a rope attached to their equipment raft until the other one reached a landing and could guide it through the rough waters.

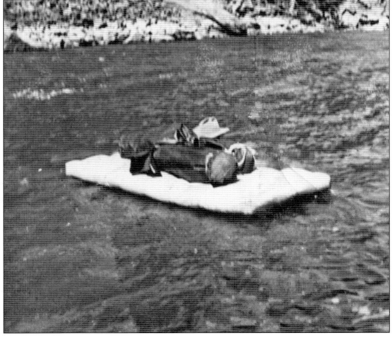

In spite of their best efforts, the rough water of the Gunnison River caused the loss of their supplies and some of their records. A.L. Fellows then wrapped his remaining equipment in waterproof covers and carried it with him even when there was no choice but to swim. The only way forward was to let the river carry them where it might.

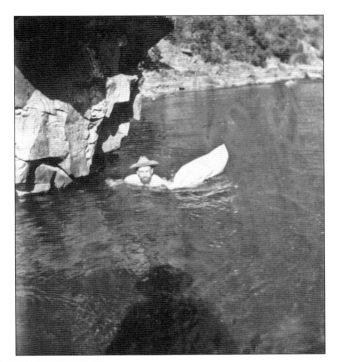

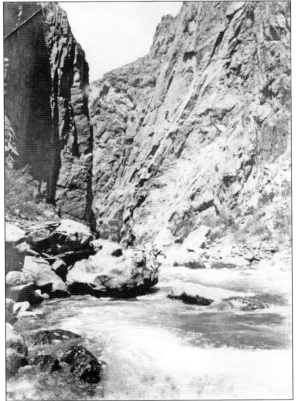

In this view looking downriver at the location Torrence and Fellows called the "Falls of Sorrow," the river roars through a narrow passage at a high rate of speed. With no alternative but to trust the river to carry them through, the men plunged into the water. They washed out, bruised and battered, to continue their journey, and emerged days later at the mouth of the canyon.

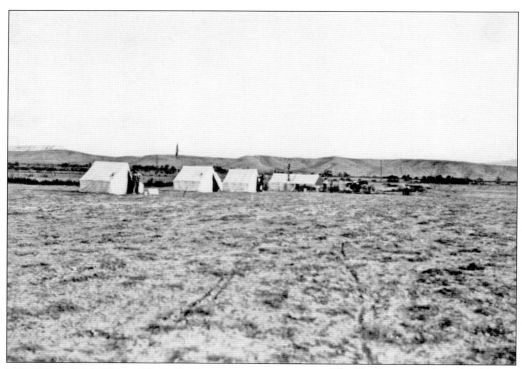

The Reclamation Act of 1902, created under Pres. Theodore Roosevelt's administration, now provided the authorization, and exploration had favored the construction of an irrigation tunnel. Government surveyors established a camp east of Montrose on Cedar Creek, from which the necessary location studies could be conducted. The Cedar Creek Camp later developed into the construction town of Lujane.

Surveying the rugged terrain required well-developed climbing skills, strong legs, and stamina. Multiple triangulations, with many setup and takedown operations, were required to measure the steep mountainsides and cliffs. The federal studies determined the best location was upriver from the old state tunnel site.

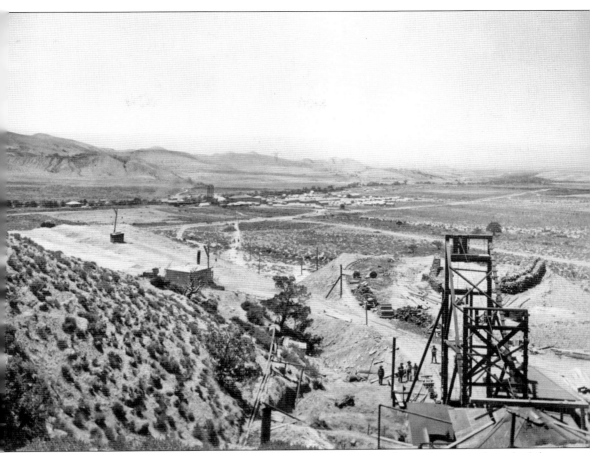

Two portal sites were established, and construction towns were located near each end of the tunnel. The River Portal community in the canyon was crowded onto the steep hillside. Lujane, laid out close to the site of the West Portal, would be the location of project headquarters. Built near the D&RG rail line, personnel, construction supplies, merchandise, and coal for the power plant were all easily transported to this location.

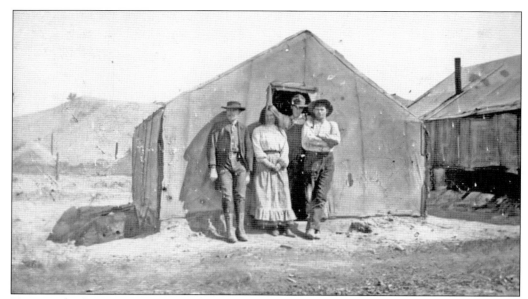

Tents at the Lujane camp were provided as living quarters for workers in the early stages of development. Frame structures were built to replace tents as quickly as possible to create an added employment inducement. Although pay was good, the average worker stay was two weeks due to dangerous conditions and hard physical labor.

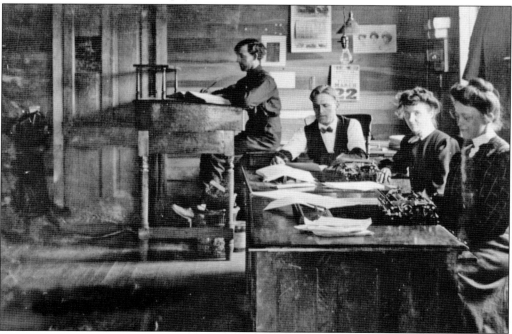

The office workers at Lujane headquarters had numerous employment records to maintain. Wages were generous for the time, with scrip, good for use at the company store, available as part of a worker's pay. Conditions in the tunnel were so hot, wet, and dangerous that turnover was high. While the average worker left after two weeks of employment, those who stuck it out were provided company housing.

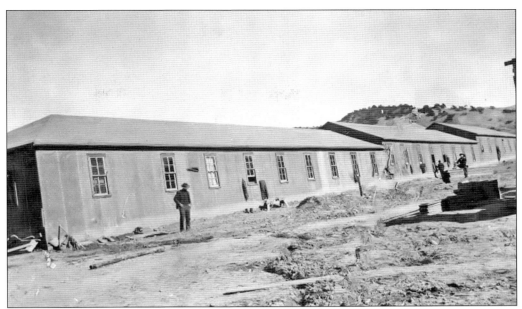

The buildings constructed for worker housing at Lujane were quickly put together of rough lumber. The walls were covered with tar-coated building paper to decrease wind penetration. Single men lived in barracks, while men with families occupied individual structures.

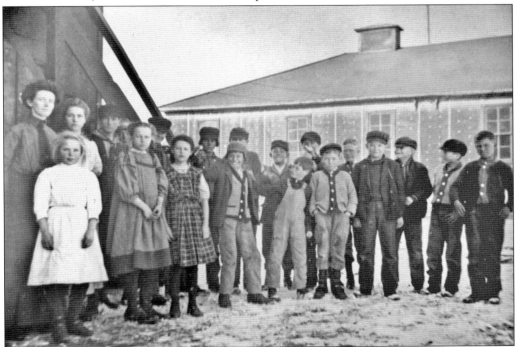

A building was provided to house a school for the children of the tunnel workers. With the frequent turnover of workers, the time a child spent in school must have been too short to be of much educational benefit. Little is known concerning the qualifications or effectiveness of the school's teachers.

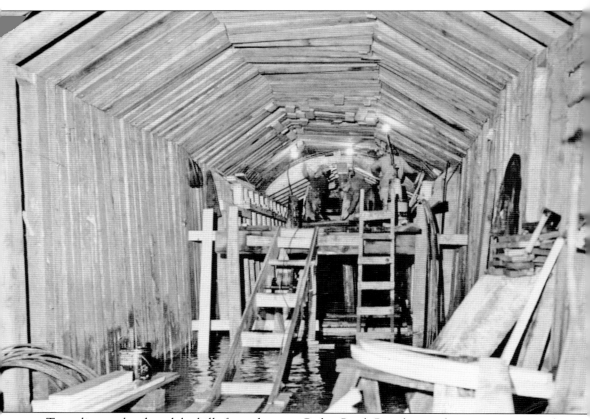

Tunneling under the adobe hills from the west Cedar Creek Portal was subject to cave-ins and ground slumping. The tunnel walls and roof had to be lined with timbering to hold excavated surfaces in place. When the bore reached solid granite deeper into the mountain, timbering was not required, but water flowing out of underground seams was a continuous problem.

A road had to be constructed to reach the work location on the floor of the Gunnison Canyon. The route from the top of Vernal Mesa, while steep with grades up to 30 percent in spots, was the only course possible. In addition to housing for workers and their families, a school, company store, boardinghouse, offices, blacksmith, and power plant created the community of River Portal.

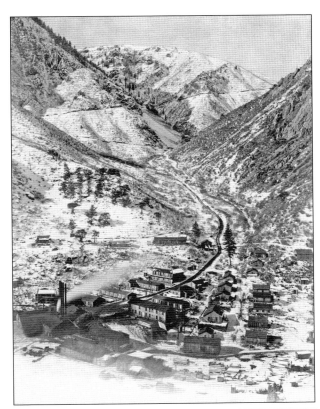

As the tunnel was dug from the river end, the rocks and tailings were dumped on the river's bank. This material was stabilized with timbers laid as cribbing, which created additional and badly needed surfaces alongside the river. The construction site and the town of River Portal made practical use of these surfaces by building on the compacted tailings.

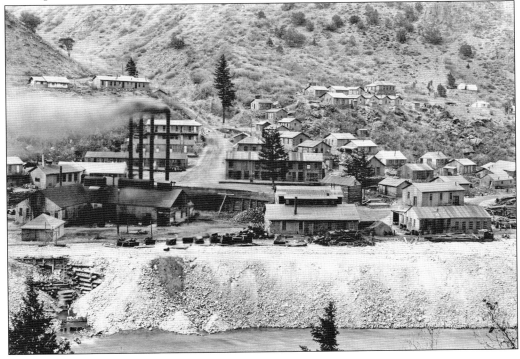

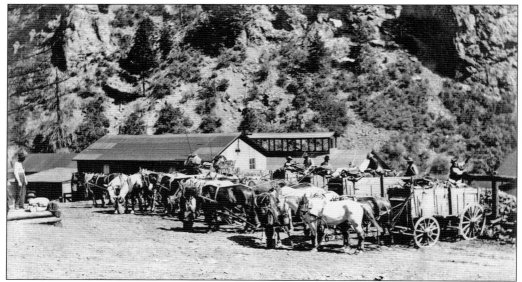

All the materials and supplies used at River Portal had to be freighted in by team and wagon, including many loads of coal for the power plant. Hauling heavy loads down the 25 to 30 percent grade of the Vernal Mesa road was very hard on the horses. Heavily loaded wagons could, and did, push teams beyond their ability to hold back, resulting in wrecked wagons, lost loads, and injured or dead horses.

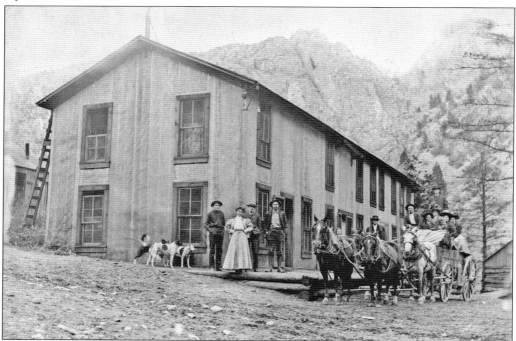

The majority of tunnel workers at this location were single men who resided in the boardinghouse. In spite of a school being provided, the living conditions at River Portal were not attractive to families. The reduced hours of sunlight, harsh winters, and enforced isolation were particularly hard on the women and children.

The meat supply for workers at the River Portal was created on the spot. Due to the freighting challenges presented by the extreme road conditions, the beef were herded down to the site under their own power. The butcher shop slaughtered the animals as the market demanded.

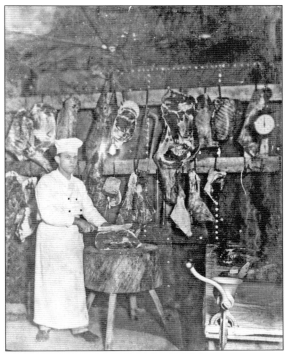

A short access tunnel provided entry at the River Portal. Workmen wore water-resistant gear but quickly became wet and miserable. They carried their lunches in fitted containers designed to hold both liquids and food. Rails were laid to service the mine cars used to haul away loose rocks and earth after blasting.

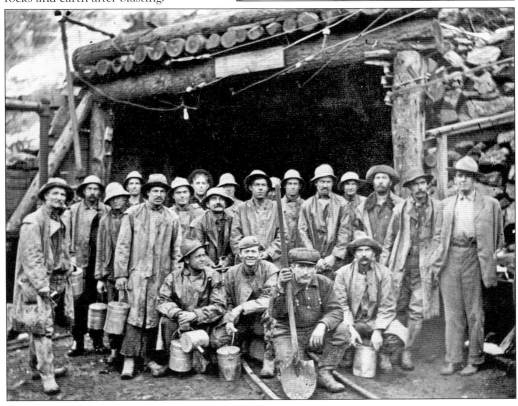

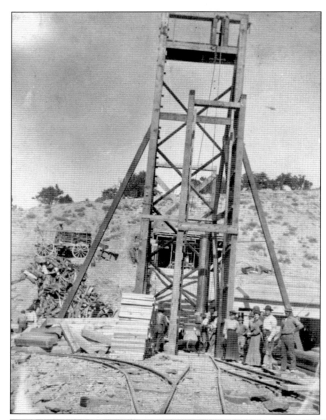

Poor air conditions in the tunnel required a ventilation shaft to be sunk from the mesa above. In addition to improving the air quality, it allowed two other faces to be worked. The bore could work both ways from the shaft, giving the project a total of four faces for drilling and blasting. Not only did the resulting debris have to be lifted to the surface for disposal, working conditions here were even more harsh, dark, and wet.

While coal-fired power plants located at both portals provided electricity for lightbulbs strung in the finished sections, light at the face was frequently supplied by candles. The lighted candle was placed in a spiked holder, then stabbed into the tunnel wall to free the workman's hands. Here, in semidarkness, one worker held the drill steel while his partner hammered it into the rock.

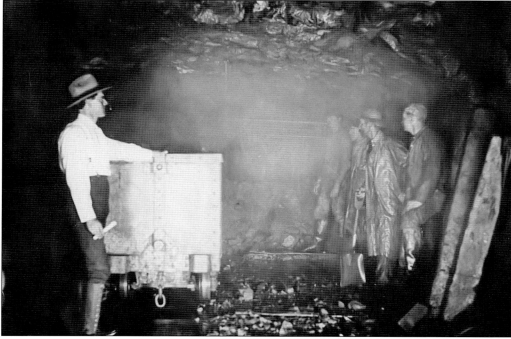

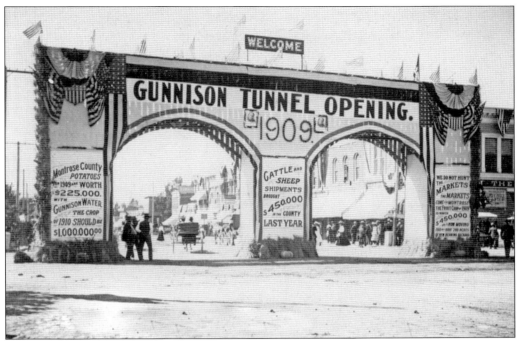

After five long years, the Gunnison Tunnel was completed, and the dedication was held on September 23, 1909. Montrose citizens constructed a double arch across Main Street to symbolize the tunnel openings. The parade route passed through the arches on its way from the railroad depot to the Montrose County Fairgrounds.

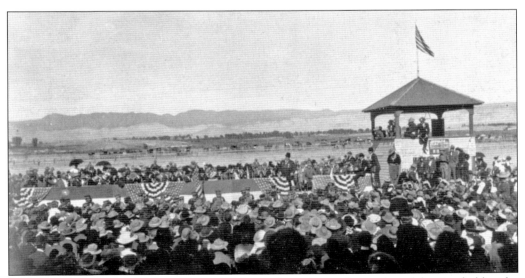

As guest of honor, Pres. William Howard Taft was the main speaker at the celebration held at the fairgrounds. He removed his hat and charmed the local audience with his words: "I am pleased to be in this incomparable valley with the unpronounceable name." They responded by telling him to put on his hat to protect his head from the sun.

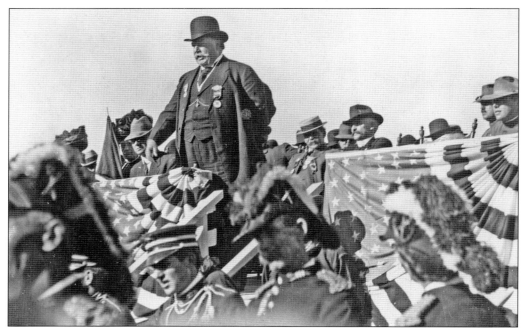

The president and special guests boarded a train to travel to the West Portal for the remainder of the dedication ceremony. There, a decorated platform had been prepared to receive the dignitaries. After years of struggles, the dream had come true, and Montrose was celebrating to the fullest. Completed in 1909 at a cost of 26 lives and $2,905,307, the 5.8-mile channel was the longest irrigation tunnel in the world. In 1972, it was designated a National Historical Civil Engineering Landmark.

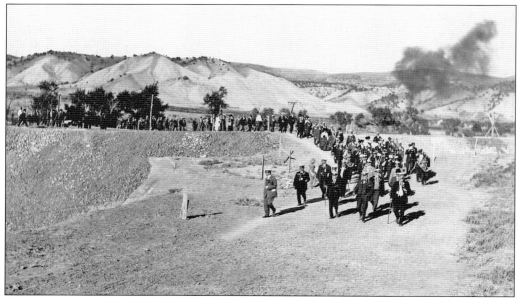

The president's short walk from the train to the stand created for the tunnel dedication was a parade of its own. He was accompanied by the band, law enforcement groups, local and state dignitaries, politicians, and invited guests.

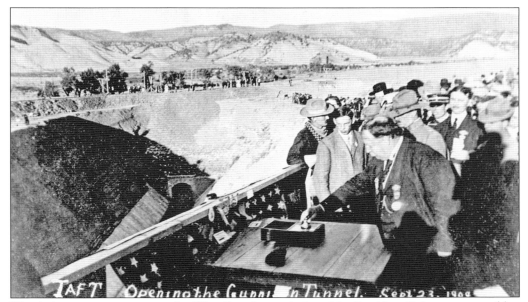

The dedication ceremonies at the West Portal were designed for President Taft to press a golden bell to a silver plate to open the headgates and allow the water to pour forth. Because final work was still taking place, river water was shut out of the tunnel. Workers built a small dam inside the tunnel to catch the abundant water seepage. When the plate was pressed, the dam opened and water emerged, to the delight of the audience.

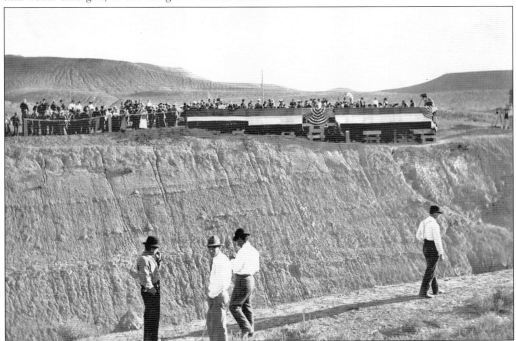

With the number of people wishing to be a part of the presence at the dedication stand, few in the crowd could really see what was happening at the portal. The best view was from a spot on the opposite side of the deep cut of the South Canal.

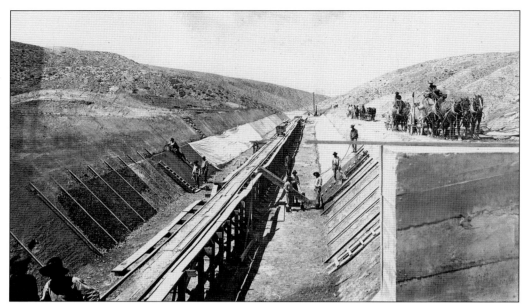

While the tunnel bore was taking place, excavation was also being done to create a canal to carry the water. The 11-mile South Canal was dug to transport the water from the tunnel to the Uncompahgre River. Because the canal traversed soft, loose soil, it also had to be lined with concrete to prevent washouts and water loss.

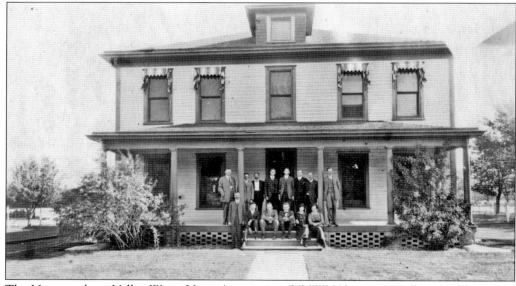

The Uncompahgre Valley Water Users Association (UVWUA) was created to provide project management. Charged with completing a canal system to deliver water to valley farms, managing the distribution of that water, and repaying the federal government for the tunnel construction costs, the UVWUA operates from the original office building at 601 North Park Avenue in Montrose. The building has been listed in the National Register of Historic Places.

Five

AGRICULTURE EXPANDS

Within days of the Ute Indians leaving the Uncompahgre Valley, settlers were already claiming the land. It would be a period of time before the government formally made the land available for homesteads, but by then, much of the acreage had been claimed and was being farmed. A ready market for produce was just a day's travel south in the bustling mining communities. The national economic depression and the repeal of the Sherman Silver Purchase Act of 1893 forced Montrose to shift focus from mining to a local agriculture-based economy.

Cattlemen operated under the open-range system, grazing herds of cattle over unrestricted ground on much of the surrounding higher elevations. As herds of cattle increased, cattlemen controlled much of the quality high-elevation rangeland by possession rather than ownership.

By 1898, sheepmen were bringing their flocks into the area to take advantage of the high-country grazing. Conflicting grazing claims led to armed confrontations, with both men and animals being killed. In spite of a March 1901 agreement that established lines between sheep and cattle ranges, disagreements continued into the 1930s. The enactment of the Taylor Grazing Act of 1934 ultimately ended major conflicts over grazing on federal land.

With the lack of adequate irrigation limiting crop yields and State Tunnel No. 3 out of funds, the US Reclamation Act became the valley's salvation. The completion of the Gunnison Tunnel in 1909 assured the availability of water necessary for successful farming in the Uncompahgre Valley. By restricting the water to agricultural purposes and limiting its use to preapproved amounts serving specified locations, the federal government assured long-term water availability for all farms and ranches.

With railroad transportation providing a means to reach distant markets, agricultural production grew quickly. The agricultural census for 1900 recorded 524 farms in Montrose County. By 1920, the census had counted 1,368 Montrose County farms. Historically, Montrose area prosperity has relied on a foundation of agriculture. Responding to the challenges imposed by insects, weather, erratic market demand, and volatile prices has always made farming a gamble. Striving to meet those challenges has resulted in the production of a wide variety of crops in the Uncompahgre Valley.

Isaac N. Pepper came to Montrose in 1906 and opened a real estate business. He purchased an 800-acre cattle ranch covered with sagebrush that was northwest of Montrose. Knowing a healthy cover of sagebrush indicated rich soil, Pepper had the brush cleared and divided the land into 10- and 20-acre tracts. Naming the enterprise Pepper's Gardens, he offered the land to small farmers

on easy terms. Pepper's Gardens provided men with limited means an opportunity to get started in farming, only requiring an investment of a few dollars and much hard work. Numerous area farmers got their start in land ownership this way.

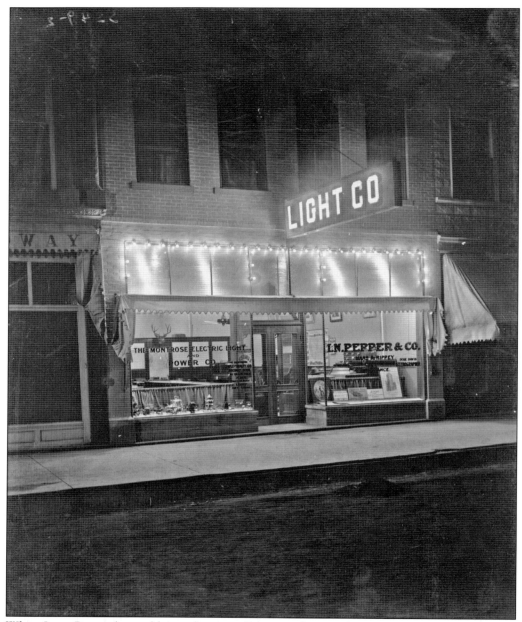

When Isaac Pepper located his real estate office next door to the Montrose Electric Light and Power Company offices, he took advantage of the attention provided by his neighbor's after-hours lighting. Land divisions in his Pepper's Garden project were legal and binding, providing subdivision plots long before they were named as such. Several present-day Coal Creek farms were put together one small plot at a time.

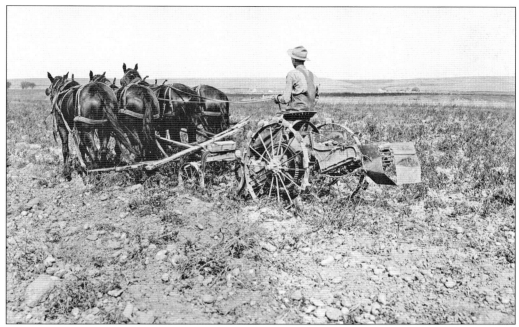

Montrose County potatoes were a leading industry in the early 1900s, setting records for size and yields of hundreds of pounds per acre. In the fall, a farmer used a machine called a potato digger that was pulled by workhorses to lift the tubers to the surface. There, the potatoes were picked up and bagged or loaded on a wagon by hand.

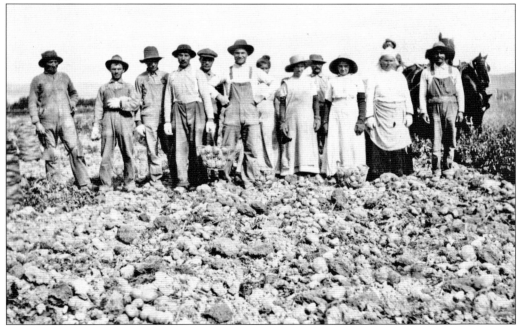

Potatoes had to be picked up as soon as possible after digging to prevent damage from sun exposure. This required bending over and gathering the potatoes one at a time. As many hands as a farmer could gather joined in the tiring task of collecting the potatoes before they were harmed.

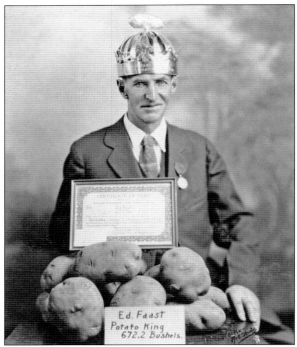

Started in 1927, the Colorado State Extension Service Potato King contests recognized potato growers raising the largest yield over a minimum of 600 bushels. Each year, one-tenth of an acre was harvested under the supervision of judges responsible for recording the yield. The farmer with the highest yield per acre was declared king. In 1937, Harry Miller was named king, with a production of 806 bushels per acre. The king from the previous year served as the chairman of the following year's contest.

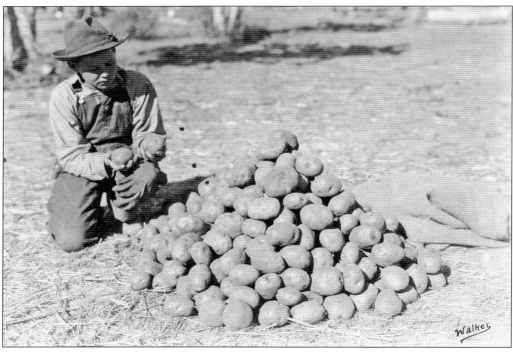

Local 4-H Clubs were encouraged to participate in the 600 Bushel Club focused on developing crop production skills in young people. As with the adult club, the producer could raise the potato variety of his or her choice. The Montrose County winner of 1930 was 14-year-old George Doudy, who also displayed his Russet potatoes at the state seed show in Colorado Springs.

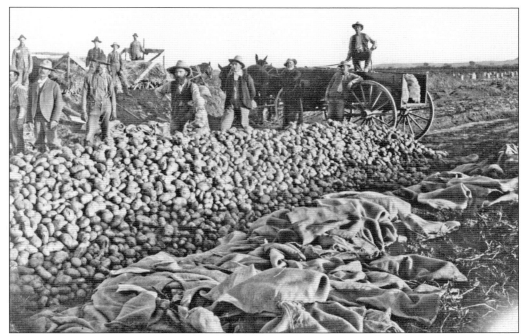

Harvested potatoes were often piled in a central location to prepare them for hauling to market. The crop was hand sorted and sacked in burlap bags holding approximately 100 pounds each. The bag was then stitched shut by hand and loaded for transport to market or storage. Potatoes are priced and sold by the hundred weight.

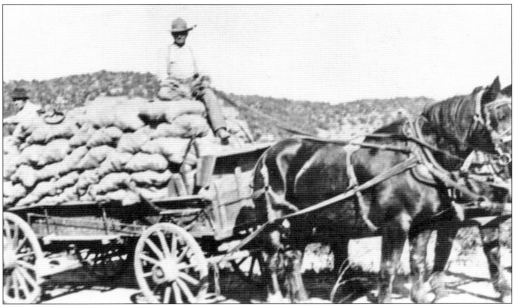

If the potato crop was scheduled for immediate sale, growers hauled the harvest to Montrose or Olathe for shipping on the railroad. Dated August 30, 1912, a letter from J.E. McDonald to family in Ohio stated, "Potatoes sold for 55 to 60 cents per hundred yesterday." This was considered a very good price in 1912.

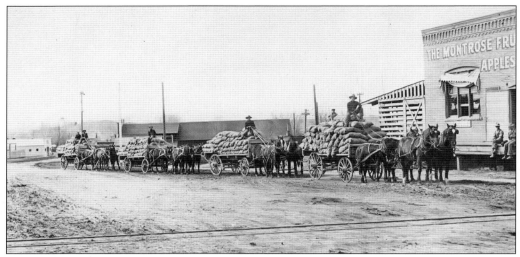

The Montrose Potato Growers was organized as a cooperative in 1923 to sort, grade, and market potatoes. They operated large storage cellars with capacities of 50 to 60 railcars. Potatoes are best stored in large, cool dirt cellars that are well ventilated and protected from light until market conditions are favorable.

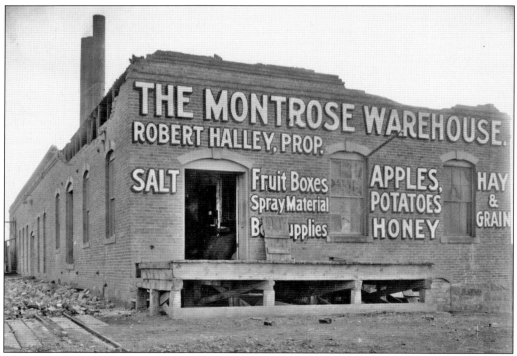

The climate of the Uncompahgre Valley, combined with soil conditions found on the area mesas, were found to be ideal for potato raising. With adequate irrigation water and dependable railroad transportation, area farmers produced rewarding crops. By 1928, membership in the local potato growers cooperative marketing association had grown to 500, the third highest in the state. By 1965, however, potato production had fallen to a level unable to supply a recently built potato chip factory.

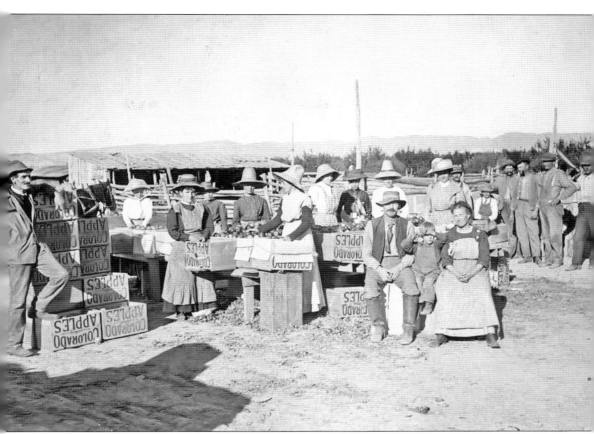

Around the 1900s, orchards became popular on many Uncompahgre Valley farms. Calling on family and temporary hired help was necessary at harvest time, but the rest of the year, a farmer could usually handle the necessary work on his own. For a time, the area had few insects or diseases to hinder bountiful crops. Around 1913, insects, freezes, overproduction, and competition from northwest states made deep cuts in orchard profits. Many trees were pulled out, and other crops were planted instead.

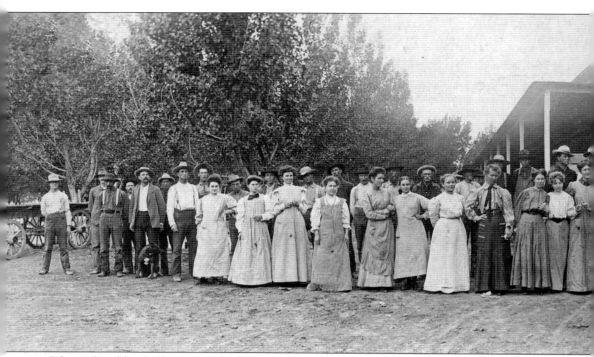

John Ashenfelter built a successful freighting business in Ouray that provided funds to invest in a large fruit orchard west of Montrose. When Fort Crawford closed, Ashenfelter acquired rights to the agency water. With water priorities two and three (the right under Colorado law to claim water), he was assured the necessary supply for raising hundreds of fruit trees. Located on Spring Creek Mesa and covering between 300 and 400 acres, the Ashenfelter orchard was devoted to

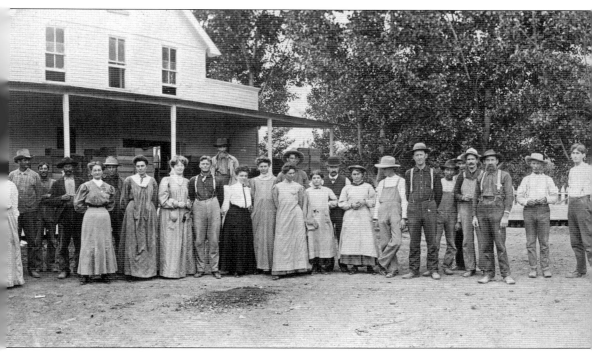

raising apples, peaches, plums, apricots, pears, and cherries. Ashenfelter crops were sold to out-of-state wholesale dealers and shipped by rail on the D&RG. Apple boxes for packing the crop were manufactured on-site, ensuring an adequate supply. The orchard was reported to employ 15 full-time people and more than 80 seasonal workers during harvest time.

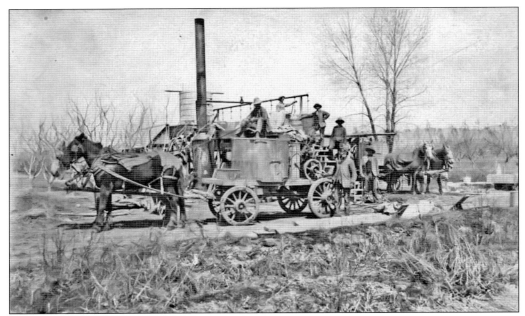

To protect against damage to the fruit, orchards are sprayed with insecticide that kills harmful insects and any fungus that might take hold. This material is also damaging to the skin of the workers and the horses coming in contact with it. Covering skin surfaces on both man and beast can help prevent contact with the spray. Washing carefully when finished reduces the risk of danger.

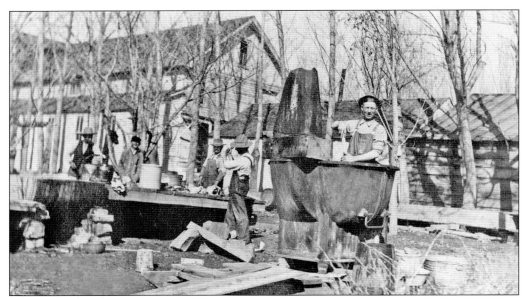

Lye was used in the drying process as Ashenfelter orchards prepared huge crops of prunes and apricots each year. Long rows of drying trays were covered with netting, followed by prepared fruit, then laid in the sun. The *Montrose Enterprise* reported that the Ashenfelter orchard shipped 10 railcar loads of dried prunes in 1903.

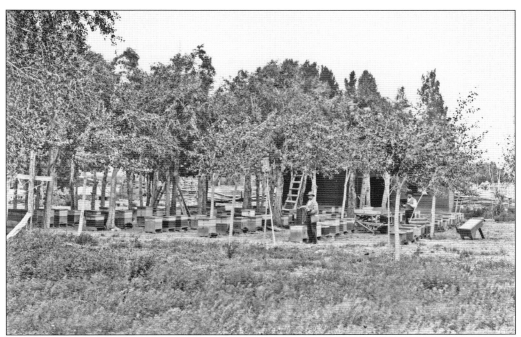

Beehives can benefit from placement in the shade of trees. Reducing the temperature of a hive decreases the number of worker bees necessary to ventilate, cool, and maintain a hive. Each spring, the hives were distributed throughout area orchards to ensure pollination of the fruit crop. As the number of orchards increased in the valley, the number of bee colonies also increased, and honey became an important commodity.

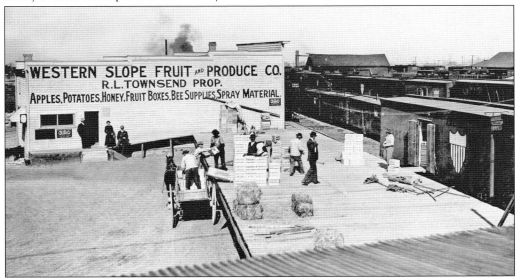

Honey was loaded on railcars for shipment out of the Uncompahgre Valley. The high quality of local honey was widely recognized, and it became a desired commodity. In 1904, honey from the Uncompahgre Valley took first place at the St. Louis World's Fair. By 1905, the number of bee colonies was reported at 5,700. With the reduction of orchards, honey is no longer an important agricultural product in the area.

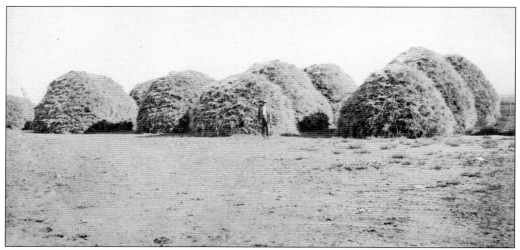

Harvesting grain crops before a binder was available required a team of horses pulling a wagon behind the mowing machine. A hayfork was used to collect the cut grain by hand and toss it onto the wagon. Once a load had been collected, it was driven to the stack ground and piled in large stacks to await the threshing machine.

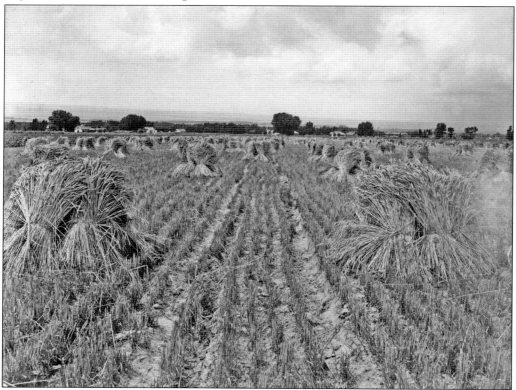

Binders were later used to cut and collect the ripened grain crops, gathering the loose stems and tying them together into bundles known as sheaves. Several sheaves were gathered by hand and stacked together, cut end down, into a freestanding collection identified as a shock. A shock was fairly weather repellent and could safely wait several days before threshing.

Ownership of an expensive threshing machine, used for a short time each year, was not practical for the average farmer. Multiple engagements of a machine throughout a harvest season was the more practical approach. Moved from field to field, a single threshing machine could serve multiple farms, and the cost of ownership could be justified.

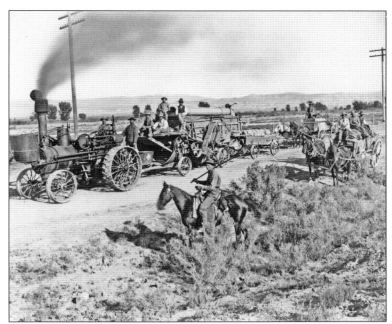

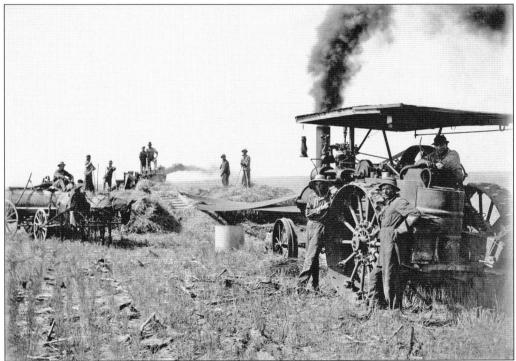

Threshing was accomplished by forking the cut grain into the hopper of the thresher. The grain was separated from the stems, and the straw was blown on a pile to the side. Power to operate the threshing machine was provided by running a wide belt between a wheel on the machine and the flywheel of an engine. Later, threshing machines were replaced with self-powered combines capable of separating the grain in the field.

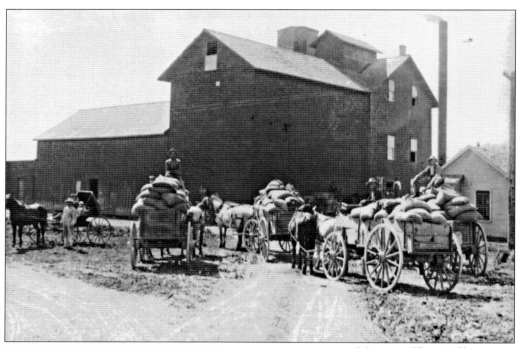

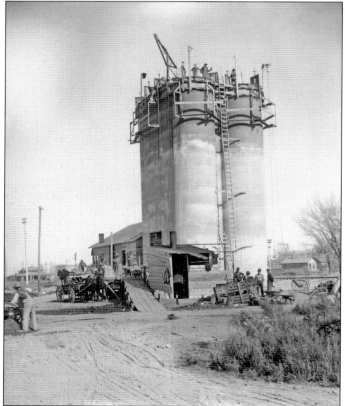

Montrose Flour Mill provided area farmers both flour and a market for their grain. As is common with flour mills, the structure burned to the ground in 1913. The mill was rebuilt but burned again on April 27, 1943, narrowly failing to trap an employee in the fire. In both fires, the Montrose Fire Department's response was limited by an inadequate water supply.

Mesa Flour Mills of Grand Junction erected a grain elevator on West Main Street in 1917. Operating under manager H.C. McAuliffe, the firm increased the area's grain marketing volume. Later owned by the Colorado Milling and Elevator Company, the elevator bought grain, cleaned it, and sold farm supplies. Sold in 1966, the elevator has since been razed.

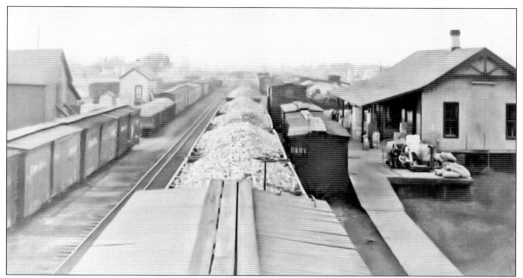

Holly Sugar built a factory in Delta in 1920 and began recruiting area farmers to grow sugar beets. Every fall until 1977, the railroad ran extra trains to move carloads of the harvested beets from rail-side dump sites to the factory. Counting both the beet harvest and attendant factory jobs, Holly Sugar contributed over $14 million yearly to the economy of the Montrose and Delta area.

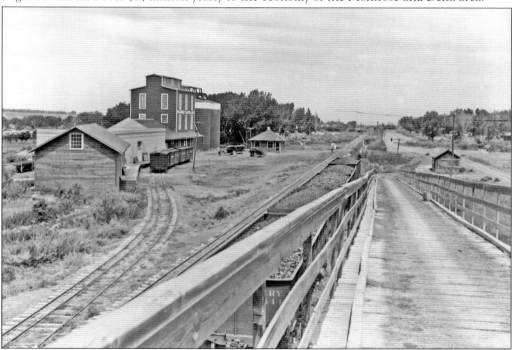

High structures known as dumps were constructed along the railroad to facilitate the loading of sugar beets in open railcars. A long ramp on either side of a central dumping area allowed access by team and wagon, and later by trucks. The load was driven up the ramp and tipped onto a chute. The wagon continued down to the ground via a second ramp. The Montrose dump was located near the flour mill rail spur.

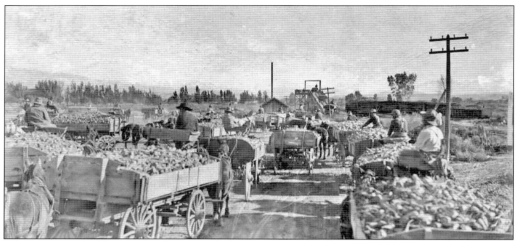

With every sugar beet grower in the Uncompahgre Valley harvesting at the same time, all of their loads of beets were hauled to the dump locations at the same time. Long lines meant long waits. It was a common practice to tend a neighbor's place in line while he ran errands and got a bite to eat, certain he would return the favor.

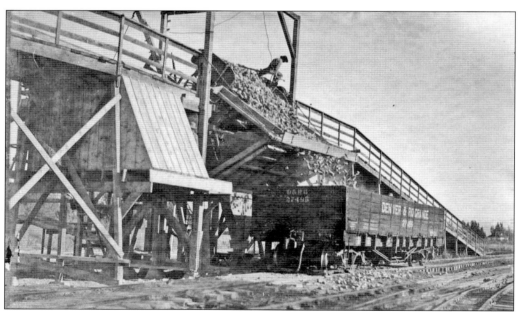

The Montrose dump was located along side rails near the flour mill spur. Beets were dumped onto a chute that emptied into the receiving railcar. This required wagons, or truck beds, to be fitted to allow dumping from the side of the vehicle. This process could be dangerous for the person serving as the dumping attendant.

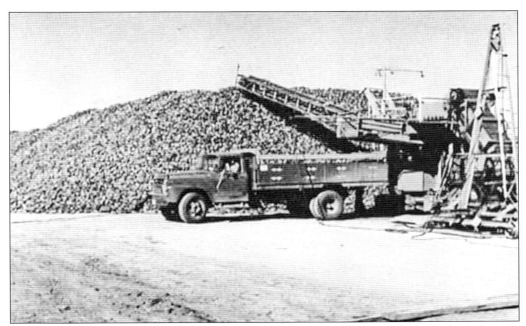

Over time, modern equipment replaced the use of the beet dump ramp. By 1961, loaded trucks were driven up to the receiving machinery, and the dumped load was transferred by conveyer to a pile of beets. The piles of waiting beets were efficiently and mechanically loaded onto the railcars without the labor, or the danger, of using the old ramps.

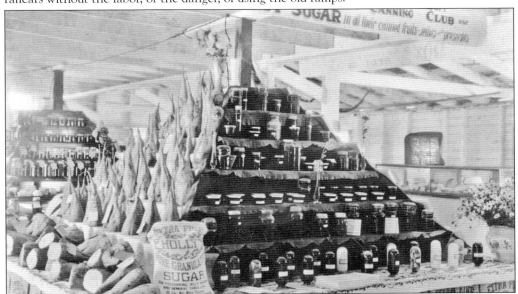

The Holly Sugar display at the Montrose County Fair explained the process of making sugar from beets and promoted the use of Holly Sugar in cooking. In the 1970s, a combination of conditions including new federal regulations, increased freight rates, and federally subsidized imports struck Holly hard. Because Holly Sugar had grown to provide an important segment of the Uncompahgre Valley economy, the 1976 closing of its western Colorado sugar operations was a major financial blow to the area.

Proof of cattle ownership depends on the brand the animal carries. Calves born out on summer range are branded when they are discovered, with family, pool riders, or fellow ranchers providing a helping hand. Identification of the unbranded calves is based on the ownership of the cow that claims and feeds the calf.

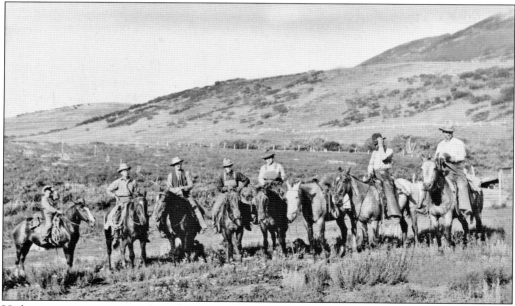

High-country grazing ground may be occupied by cattle herds belonging to several different ranchers at the same time, known as a pool. Working as a self-organized group in a cooperative fashion, each ranch contributed cowboys to provide the necessary riders. Checking cattle, doctoring injured or sick animals, branding caves, and gathering in the fall was done by the pool riders.

Early livestock sales, such as this 1917 bull sale, were often held at a location on West Main Street and Grand Avenue known as the Elephant Corrals. The name was acquired as a result of housing visiting circus elephants near the railroad. Used as a livestock sale barn for many years, the building was estimated to be close to 100 years old when it was razed in 1956.

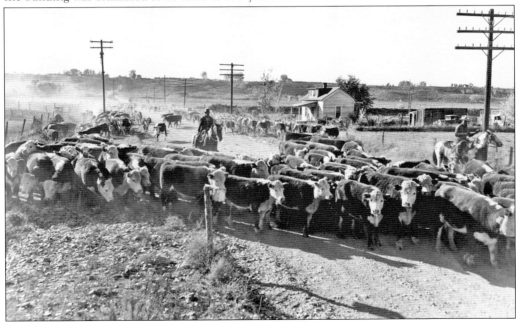

Montrose was considered a cow town by area cattlemen. Any movement of cattle herds from one location to another went down the streets of town, if that was the shortest route. While effort was made to avoid causing damage to property along the way, this practice was and is quite legal because Colorado is, by law, an open-range state. In later years, highway traffic has curbed the practice of moving cattle on roadways.

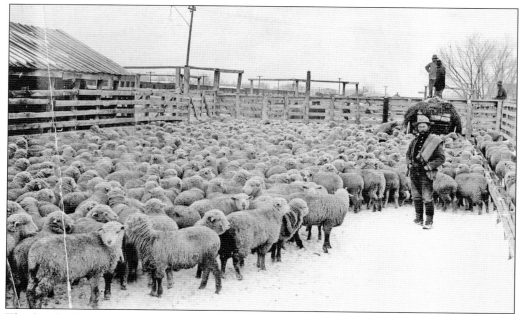

The first herds of sheep came into the Uncompahgre Valley in 1882. The good grazing on the open range attracted the sheepmen just as it had the cattlemen. By 1898, area cattlemen saw the large numbers of sheep as a threat to unlimited cattle grazing. Range wars broke out with armed confrontations. In 1909, a line designating the area north of the Gunnison River as sheep range was determined, but not all abided by the border.

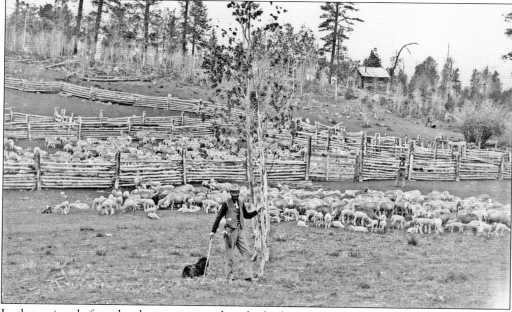

In the spring, before the sheep are moved to the high-country pasture, they must be sheared of their wool. The flock is gathered in a holding pen for sorting, whereby individual animals are separated, sheared, and turned out. After ewes reunite with their lambs, they are ready to be moved to summer grazing.

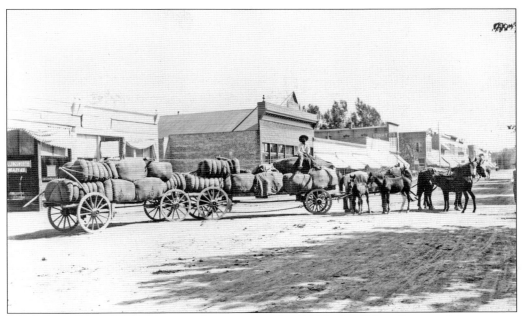

A long load of wool, packed into sacks, pauses in the 200 block of Main Street in Montrose on the way to market. In 1885, Montrose County was reported to have produced one million pounds of wool clip. The horse team includes mares that are mothers to the colts alongside. This practice was not unusual, as distances traveled often prevented a return that allowed the nursing mother to feed her offspring.

The lamb and wool production in Montrose County was an important industry for many years. Many sheepmen had headquarters in the Uncompahgre Valley, feeding their sheep on crop residue during the fall and winter, then lambing and shearing in the valley before moving to the high-mountain grazing during the summer.

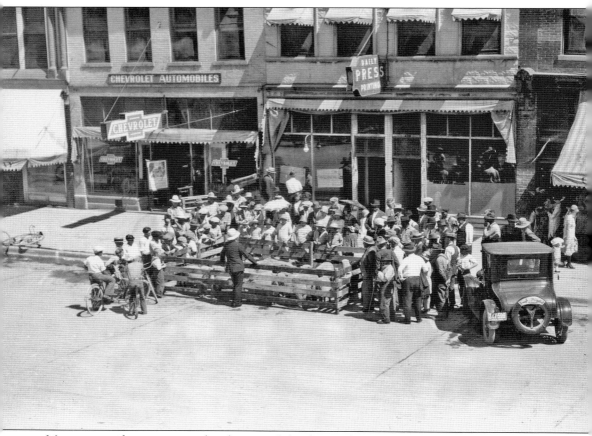

Montrose residents recognized and accepted that livestock were an important component of the area economy. This was true to such a degree that a 1926 sheep auction held on Main Street in front of the *Montrose Daily Press* was accepted as an interesting but matter-of-fact event.

Six

A Community Develops

When Montrose was founded, it was little more than a collection of shacks along the railroad tracks in a dry, barren valley surrounded by natural wonders. Its growth from that beginning to a thriving community was due to flexibility and meeting challenges with an ongoing change of focus.

Initially, the formation of the town was based on a prediction of prosperity flowing from a transportation connection to the railroad. Access to the railroad provided the mining districts in the San Juan Mountains with a reduction in ore shipping expenses, and Montrose businesses had an assured market for goods and supplies.

As setters arrived with the opening of homestead lands, the number of local merchants increased to service an expanding customer base. Hardware stores added farm equipment and household goods to their inventory of mining supplies, other merchants expanded their stock of dry goods, and grocers increased their selections.

With the addition of families, Montrose residents changed their expectations, and the community became more stable. The arrival of legal and medical service providers added to the stability as churches and schools led a gradual transformation from the numerous saloons and gambling halls of earlier days.

The national economic depression and the repeal of the Sherman Silver Purchase Act of 1893 forced Montrose to shift focus from mining to a local agriculture-based economy. Railroad transportation enabled farm and orchard produce to reach national markets. The availability of water through the Gunnison Tunnel increased farm and ranch production, causing agriculture to become the foundation of prosperity for Montrose.

As the town grew, refinement and cultural developments became more important to the population. Fraternal organizations and social associations formed for literary, social, and philanthropic purposes, with the aim of improving the quality of life in Montrose. Many of the community advancements and developments grew from the activities of the service clubs.

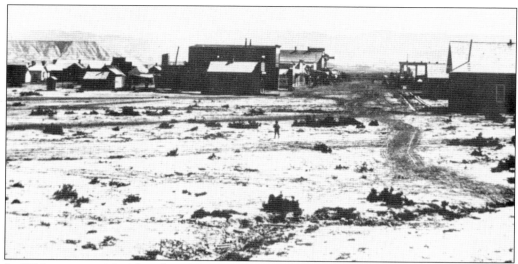

In 1884, two years after founding, Montrose still fit the description of a collection of shacks on a dusty, barren patch of ground. There were a handful of young business endeavors and a more-than-adequate supply of saloons.

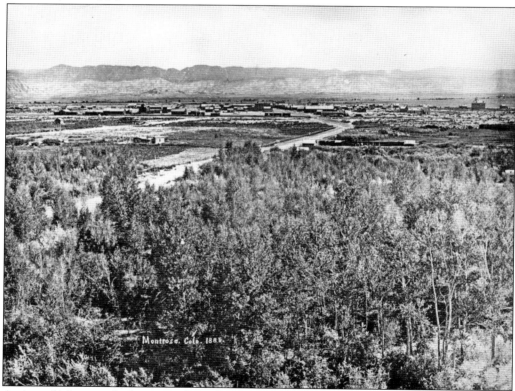

A view of Montrose looking east from the end of Sunset Mesa reveals the barren nature of the site in 1885. Substantial buildings were still rare, with Central School an obvious exception. The trees in the foreground are situated along the Uncompahgre River, the only source of water necessary for their growth.

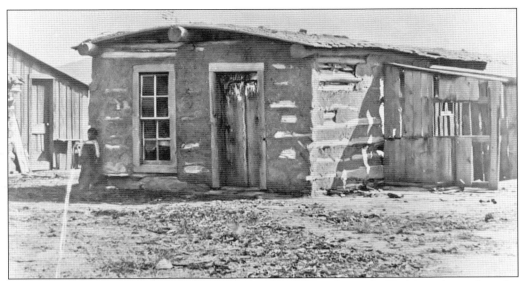

The majority of structures in the 1880s were constructed similar to the Diehl residence. Logs for walls were stood up palisade fashion, then were plastered over with mud to seal the cracks. A notched log cabin style was used if thicker logs were available. Structures of sawn lumber were often of the board-and-batten type, with narrow strips of lumber used to cover cracks between the vertical boards.

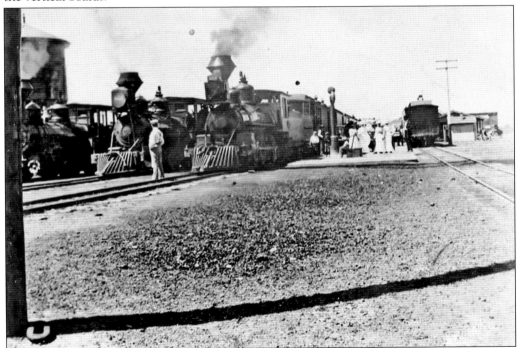

By 1890, Montrose's growth had become apparent at the depot. Despite continued use of the old original depot building for passenger service, travel on the railroad was popular. Multiple tracks provided for switching, and engines moved back and forth to reach loading docks and the water tank at all hours of the day.

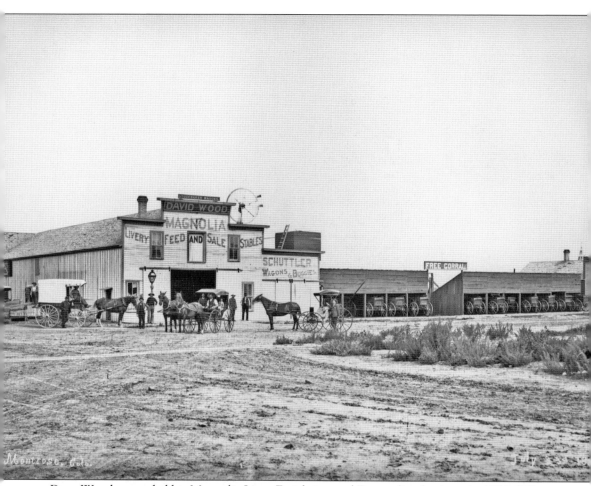

Dave Wood expanded his Magnolia Lines Freighting and Forwarding business in 1886. Offering livery stables, buggies and wagons, feed sales, and a free corral, the operation grew to fill most of a city block. His huge new barn was built to include 75 stalls. In the spring of 1884, he constructed the Dave Wood Road from Montrose to Leopard Creek to eliminate the problems presented by the Otto Mears Toll Road over Dallas Divide.

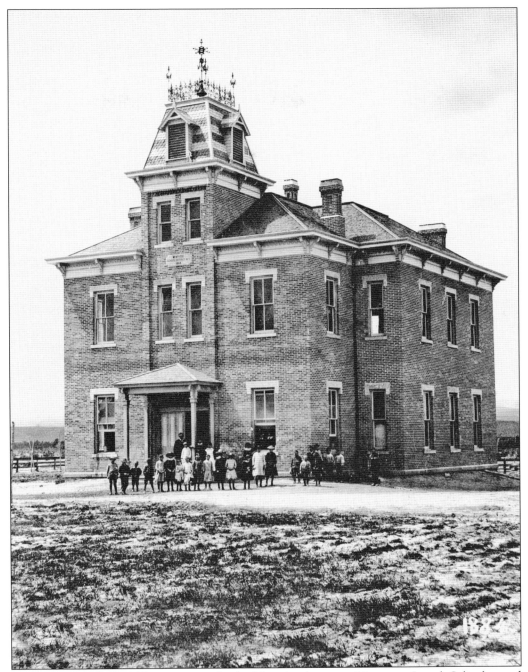

In 1883, a bond for $8,000 was approved to build a school to serve Montrose. Joseph Selig donated a block of land between South Second and South Third Streets for a school location. Known as Central School, the two-story brick building served area high school students on the upper floor, with the ground level devoted to the younger children. By 1900, the structure had been enlarged to contain 12 rooms. Over time, several wings were added to make the structure large enough to serve 700 children.

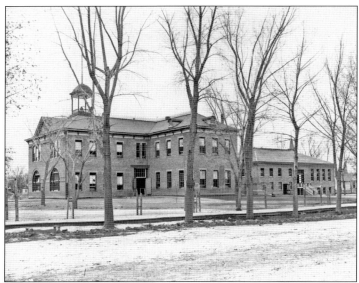

Central School was expanded over the years, with the final addition made in 1905. In 1923, most of Central's building was condemned, and all but the 1905 addition was torn down. The replacement building was constructed of bricks from the local plant, as designed by architect Temple Buell, with labor provided by the WPA. The Morgan School, named for longtime educator John B. Morgan, was accepted on July 13, 1936.

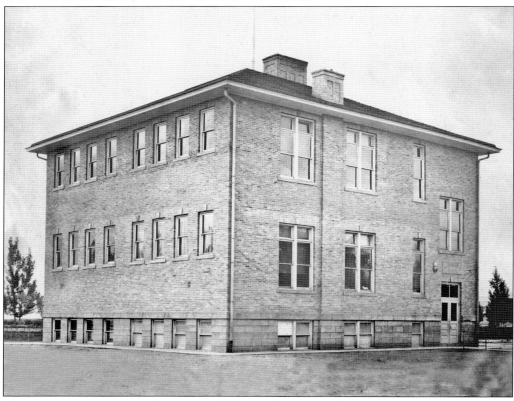

The Johnson School was built in the 1000 block of East Main Street in 1910. Named for school board president Dr. R. Johnson, the building received its first and only addition in 1914. In 1975, the school board sold the site to the McDonald's restaurant chain and built a new Johnson School next to the new Centennial Junior High. This site was later turned over to the junior high, and another new Johnson School was constructed east of Montrose off 6700 Road.

The older students attending Central School were educated based on a high school curriculum, and by 1893, two students had graduated, concluding their three years of high school. By 1895, seven students had received certificates of graduation. While some years produced no graduates, the number of graduating students had increased to 12 by 1903. In 1904, the final year of the three-year high school, 15 students graduated.

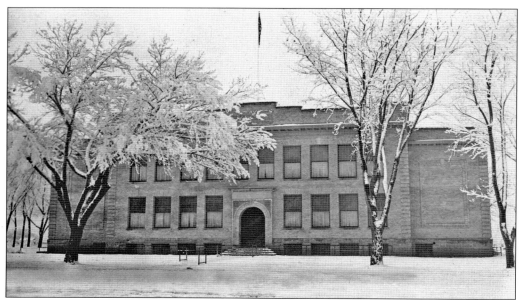

In 1904, Montrose high school students moved to a new brick building between South Ninth and South Tenth Streets. Over the years, several additions were made to this building to accommodate an increased student population. Several frame structures were also erected on the site to accommodate specific classes. This facility remained in service until 1940, when a new Montrose High School was built on South Townsend Avenue. A portion of the old high school was used for a junior high school before being torn down.

A new building was constructed to house Montrose County High School in 1940. Located on South Townsend Avenue, the school was intended to house grades 9 through 12. For a time, this configuration was reorganized to serve grades 10 through 12, with the freshmen moved to the middle school. After multiple additions to the facility, the renamed Montrose High School returned to a four-year curriculum and remains so today in enlarged and expanded quarters.

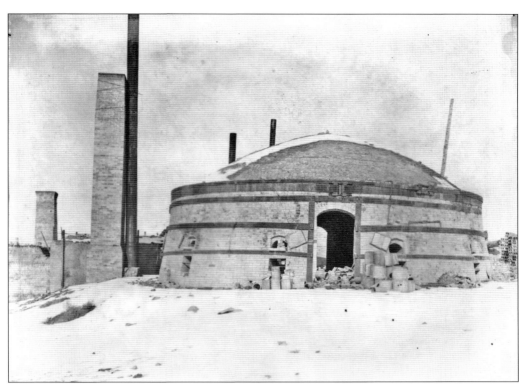

The Buckley Brick and Tile plant was built on the north end of Sunset Mesa in 1907. Local shale was ground to powder, dampened, placed in molds, and subjected to 75 tons of pressure. The hardened forms were then placed in the kiln and fired to the desired finish. Many local buildings were constructed of bricks from this plant.

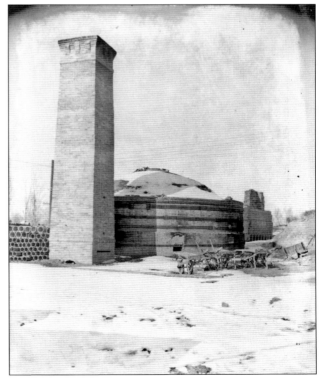

The Buckley plant was sold to L.R. Allen in 1912. In 1920, the Montrose Brick and Tile Company reported the production of more than one million bricks. Clay tile produced at the plant (stacked left of the chimney) was manufactured for drainage of excess water collected in natural low wet spots or as a result of poor runoff from crop irrigation.

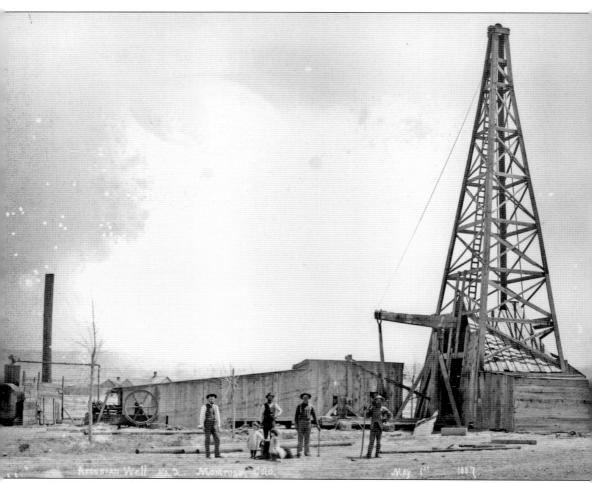

Robert L. Smith, head of the Montrose Water Department, is credited with drilling Artesian Well No. 2 near the corner of South First Street and Uncompahgre Avenue. The water was highly mineralized, with a strong taste and odor, but without the heavy alkali contamination found in most of Montrose's water. When the rusted-out casing was replaced in 1907, it was moved across the street, and T.B. Townsend donated an iron fountain. The Montrose community has long referred to the continuously flowing water as the "Iron Mike," which is rumored to have been named after Mike the fire department dog.

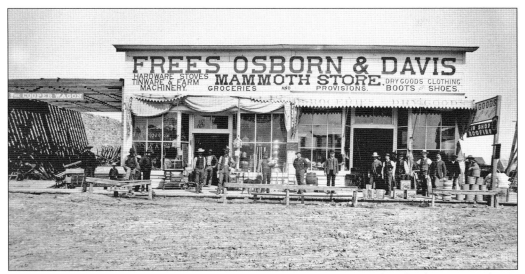

E.L. Osborn came to Montrose in 1883 and went into the general merchandise business with J.C. Frees and others on the corner of Main Street and Uncompahgre Avenue. By 1898, Frees, Osborn & Davis had increased their offerings to an expanded line of general merchandise, hardware, and farm machinery. In 1890, Osborn sold his share, the hardware business, to J.V. Lathrop and went into banking.

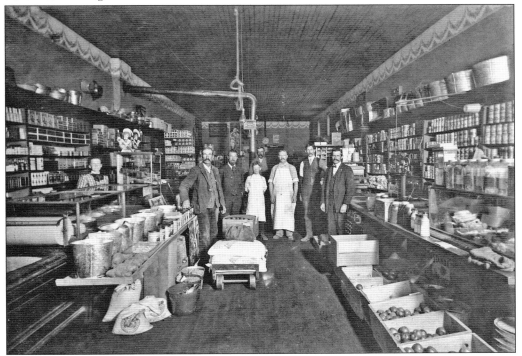

The interior of J.C. Frees Grocery reveals the wide assortment of merchandise available to Montrose customers. The inventory included food items, kitchenware, dry goods, and hardware stock. Growing with the town, the store was considered a leader in service, with customer credit available to established patrons.

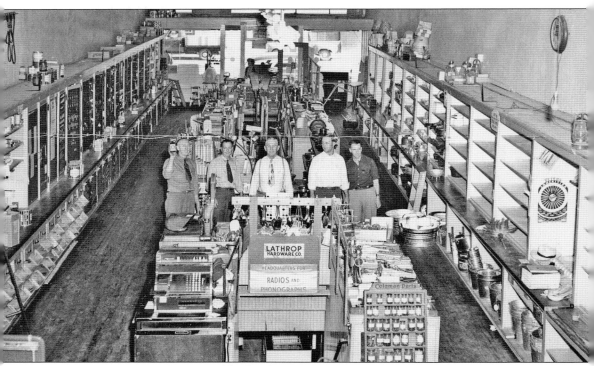

J.V. Lathrop successfully operated his hardware business just a few doors west of J.C. Frees's general merchandise store. Meeting the needs of the community it served, the hardware firm prospered in the same location for decades. Lathrop built such a reputation as an honest, fair merchant that, when the hardware store was sold, the later owners continued to conduct business under the Lathrop Hardware name.

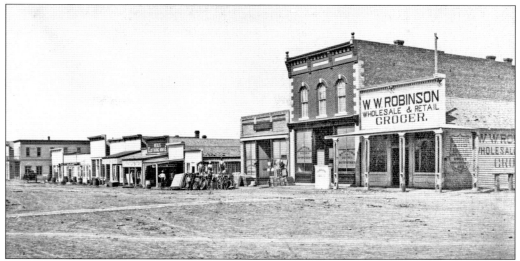

T.B. Townsend, a mining engineer from England, moved to Montrose in the early 1880s and opened a hardware store in a small building next door to the two-story brick Buddecke & Diehl building on Montrose's Main Street. The adjoining lot to the west displayed a Deering mowing machine and hay rake as examples of the farming merchandise offered by the Townsend Farm Implement and Hardware Company.

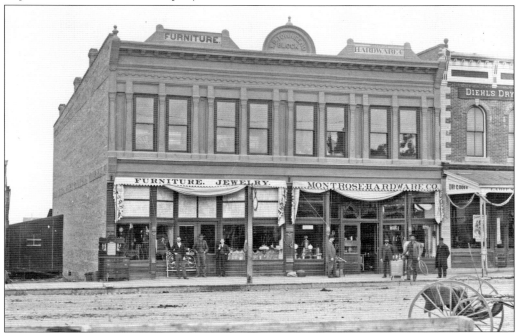

Townsend replaced the small Montrose Hardware building with a new two-story brick structure between 1886 and 1889. Known as the T.B. Townsend Block and managed by Bert Cornish, the larger quarters offered a line of quality furniture and greatly expanded hardware stock. The Montrose Hardware Company became one of the anchor businesses on Montrose's Main Street, offering a wide variety of farm equipment, including walking plows, plowshares, harrows, hand tools, buggies, and wagons. Montrose Hardware could fulfill the farmer's every need.

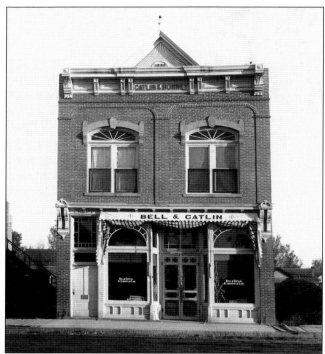

Attorney Frank D. Catlin came to Montrose in 1884. In 1890, with his partner, A.L. Bonney, Catlin built a brick two story building on East Main Street to house their law practice. Over the years, Catlin served in local, county, and district legal offices, or joined in partnership with several different attorneys. He is best remembered for his work as the first president of the Uncompahgre Valley Water Users Association, serving as chairman of the 1909 opening of the Gunnison Tunnel and as host to President Taft.

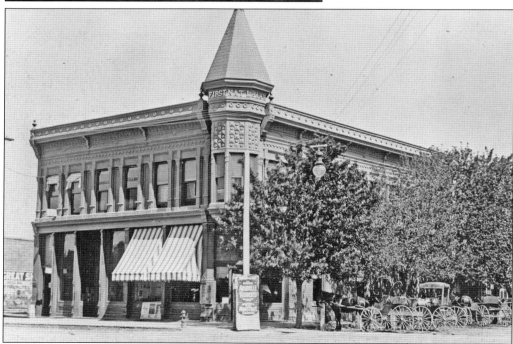

The First National Bank was established in 1889, and soon after, a new bank building, topped with a distinctive cupola, was completed on the corner of Main Street and Cascade Avenue. Montrose Dry Goods occupied the east side of the ground floor, while the second story contained rental apartments. The hitching rack along Cascade Avenue was installed in 1898.

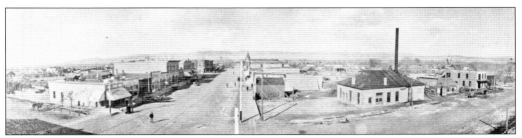

By 1908, Main Street had begun to resemble a permanent settlement. Several two-story brick structures had been built, and the business district covered just over three blocks in length. Montrose Power Company, with a tall stack for the smoke from burning coal, was providing electricity to light the intersections of the main streets.

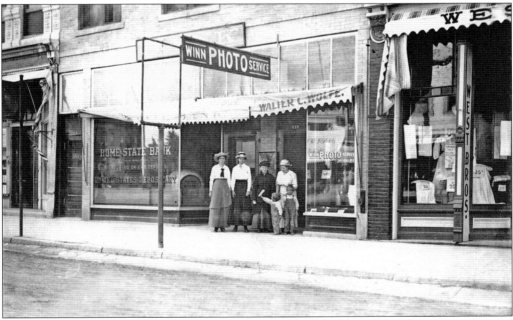

While Montrose had grown to contain many substantial brick buildings, Main Street was not paved until 1919. The ladies of the community complained about the dirty and uneven wooden sidewalks, even taking their campaign to the newspaper. The ladies finally pressured the town fathers into installing cement walks, even though the streets remained the original dirt surface.

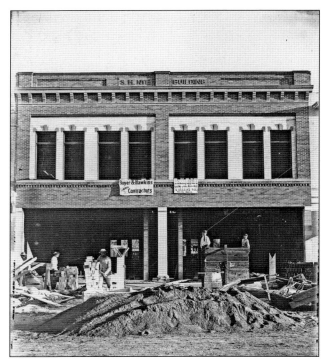

Samuel H. Nye, one of Montrose County's first three commissioners, erected his namesake building at 428 Main Street in 1908. He had established one of the area's first orchards, ordering his first trees by mail, with delivery through the post office that served the military at the Cantonment on the Uncompahgre. The Nye Building was later donated to the Congregational Church and sold to raise money to benefit the church.

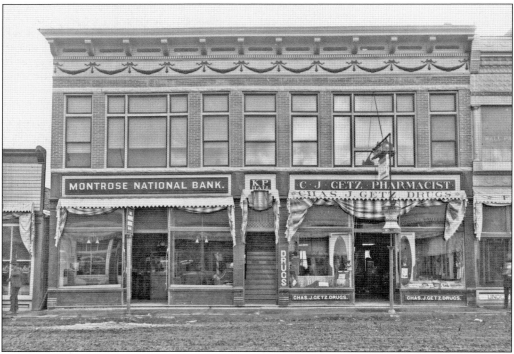

Charles J. Getz constructed the Getz Building to house his popular drugstore and the Montrose National Bank. The Knights of Pythias fraternal order used the second floor as a lodge hall until they erected a permanent lodge building on the corner of Cascade Avenue and South First Street.

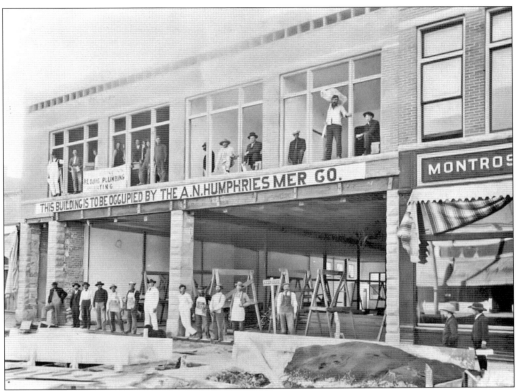

The construction of A.N. Humphries Mercantile Company on Main Street in 1905 was an indication that business growth was continuing, and citizens followed the building's progress in the local newspaper. This well-built structure at 307–309 Main Street continues to house retail shops and offices today.

Brothers Joe and Sid Hartman began business as a bicycle repair shop on Cascade Avenue in 1904. They expanded into a garage servicing early automobiles, and in 1908, their shop became the first Ford dealership in western Colorado. In 1912, the brothers acquired three lots in the 500 block of Main Street and erected a large brick building at a cost of $20,000. They operated automobile dealerships at this location for many years.

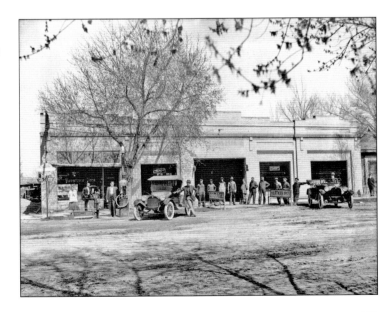

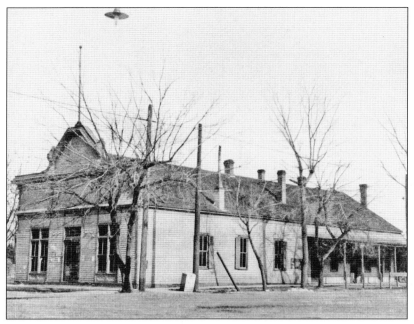

Montrose's first county courthouse was located in the roller-skating rink belonging to county clerk Joseph Selig. At first, the county's business required only the front portion, allowing space for a library reading room in the rear. In spite of the county's growth, this location served as the Montrose County Courthouse for more than 38 years.

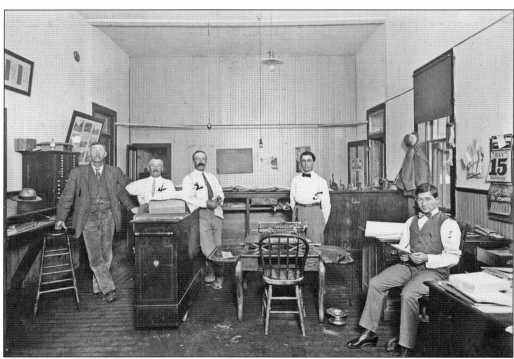

Townsend W. "Tony" Monell (third from left) served as Montrose county clerk for 24 consecutive years. Known as an active and dependable civic booster, he served as secretary of the Colorado State Association of County Commissioners for 23 years, and was active in both the Western Slope Fair Association and the Uncompahgre Valley Cattle and Horse Growers Association. At the time of his death in 1941, Tony was serving as the Montrose postmaster.

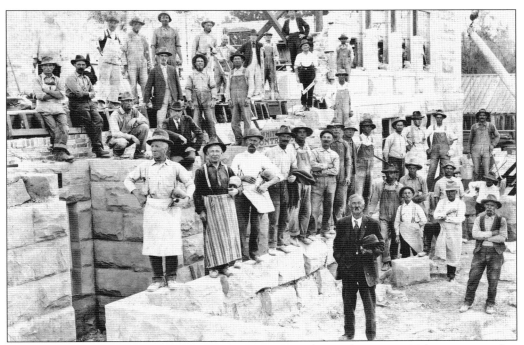

Stone for the Montrose County Courthouse was quarried from the August Kaleway quarry, five miles west of Montrose. The 4,000- to 6,000-pound blocks were hauled to the building site and dressed to size on location. In compliance with the architect's desire and a county directive, all labor and all construction materials were to come from local sources if possible.

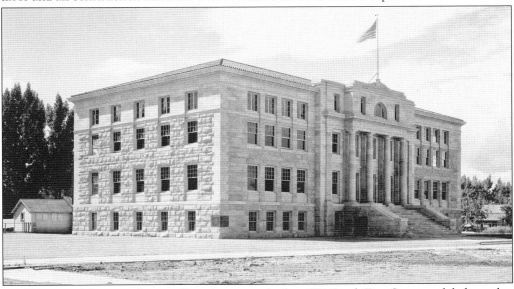

In 1922, a new Montrose County Courthouse was built at 320 South First Street and dedicated as a memorial to the county's World War II service men and women. Designed by architect William N. Bowman, the three-story structure featured a circular opening through two floors to the top level. Local sandstone was used instead of brick to construct the exterior walls. It was listed in the National Register of Historic Places on February 18, 1994.

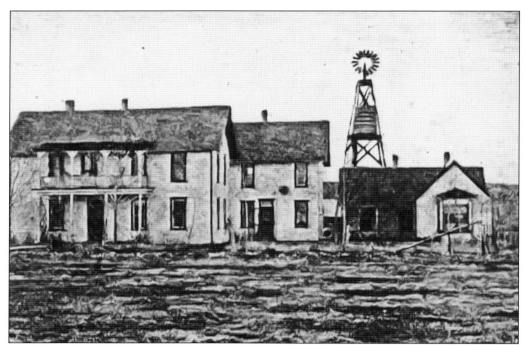

The first hospital in the vicinity of Montrose was located a few miles south of the town. The Hartman family established the hospital in the Riverside community around 1905. Intended for the treatment of tuberculosis patients, the hospital's shortage of such patients quickly became apparent. As the only hospital in the area, the sanitarium accepted anyone in need of medical services.

Area supporters had been collecting donations, fundraising proceeds, and community contributions for a new modern community hospital in Montrose since 1946. A ground-breaking ceremony with Woman of the Year honoree Anna Fender, owner of St. Luke's Hospital, moving the first shovel of dirt was held in 1947. Following its completion, the Montrose Memorial Hospital was dedicated in March 1950.

Dave Woods freighted a printing press from the end of the railroad line in Gunnison to Montrose in 1882. Abe Roberts began the first newspaper in Montrose, naming his publication the *Montrose Messenger*. The first issue was sold at auction to Joseph Selig for $10, and the second copy was sold to William Eckerly for $5. Located at 512 Main Street, the paper continued its weekly publication until 1904, when it was sold to Charles E. Adams and the name was changed to the *Montrose Press*.

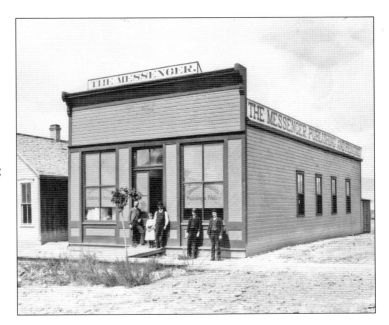

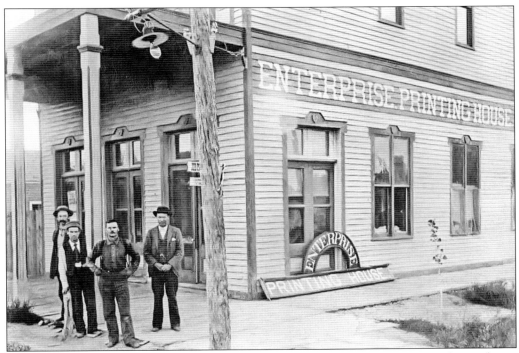

The Enterprise News and Printing Company occupied a two-story frame structure at the northwest corner of Main Street and Townsend Avenue in 1905. The weekly newspaper was known for the editor's sense of humor and cartoon drawings of community figures. The business relocated to the Hodges Building on Townsend Avenue before being purchased by and absorbed into the *Montrose Press* in 1922.

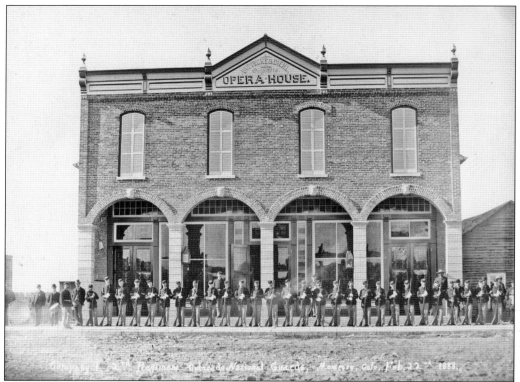

In 1887, Buddecke and Diehl constructed a brick opera house on the corner of North First Street and Front (later Townsend) Avenue to also serve as the local armory. The City of Montrose passed an ordinance forbidding the charging of fees for opera house use. Maintenance costs might have been the reason for another ordinance limiting fees to $20 in 1894. The local National Guard unit occupied this location until a new armory was dedicated on the corner of South Twelfth Street and Townsend Avenue in 1956.

The limitations of the old Second Street armory, along with federal requirements, supported the construction of a new armory. Lots were selected near the outskirts of Montrose, and a new armory was built on the corner of South Twelfth Street and Townsend Avenue in 1956. With ample rooms for offices and classrooms, the new structure also provided a large garage and grounds for equipment parking.

During the Great War in 1914, few residents had access to news on the conflict other than through the newspaper. The *Montrose Daily Press* posted the newspaper in the Main Street shop window so people could read the news of the day. Bulletins from World War I and the war in Mexico were of particular interest to locals, as family members and neighbors were serving in the military.

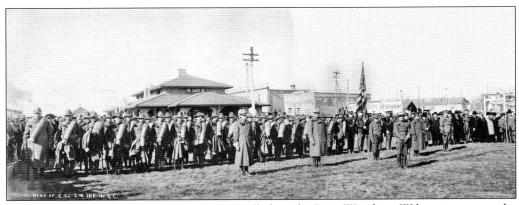

Colorado National Guard E Company was called out by Pres. Woodrow Wilson to protect the US-Mexico border from raids by the bandit Pancho Villa. Their return, on February 24, 1914, was marked by a company photograph at the Montrose depot.

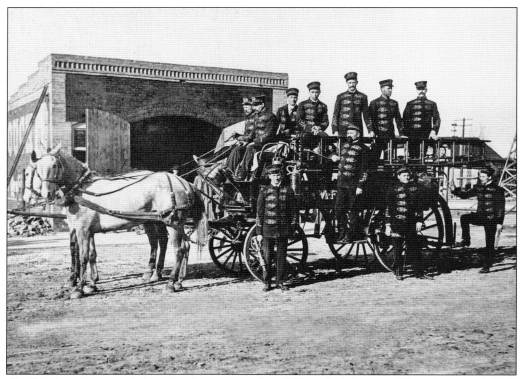

The fire department in Montrose first organized in 1888 as the Montrose Hose Company No. 1. In 1906, they reorganized as the Montrose Fire Department. They were housed in a building on North First Street when they acquired new uniforms in 1909. Fire chief Jim Donnelly proudly tended the fire wagon and the fire horses, Maude and Queen, until Montrose purchased a modern fire engine in 1923.

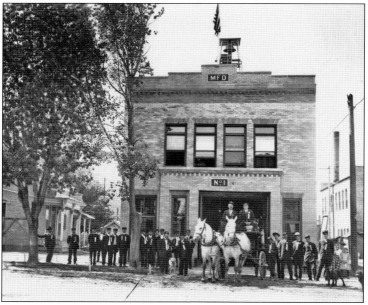

The fire department moved into a new brick station in June 1910. Built of Buckley pressed white brick, the modern structure cost a total of $6,000. Located along the alley on South Uncompahgre Avenue, it was topped with a steel tower supporting a 1,000-pound fire bell. Though a more modern siren replaced use of the bell, it remained in place until it was relocated to a place of honor in front of the new Fifth Street station on September 30, 1981, as a tribute to past firefighters.

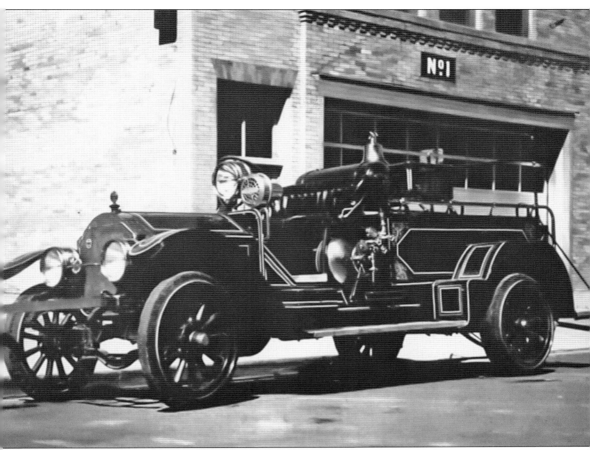

The Montrose Fire Department replaced the fire horses with an $8,000 LaFrance combination chemical and hose car on July 16, 1923. The city council appointed two firefighters to be drivers, Jim Donnelly and Millard Barsch. Nicknamed "Leaping Leena," the fire truck's long service earned it a special spot in the heart of the community. After Leena was retired in 1944, she was often the lead vehicle in parades and frequently transported Santa at Christmas.

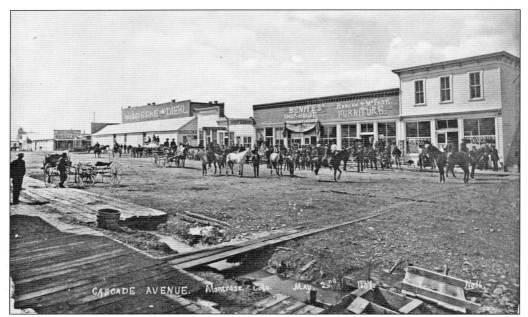

With postal service becoming more important to Montrose residents by 1887, the US Post Office moved into a small frame building in the alley behind Buddecke & Diehl Outfitters on North Cascade Avenue. Located in the heart of early Montrose, this site provided easy access for all patrons.

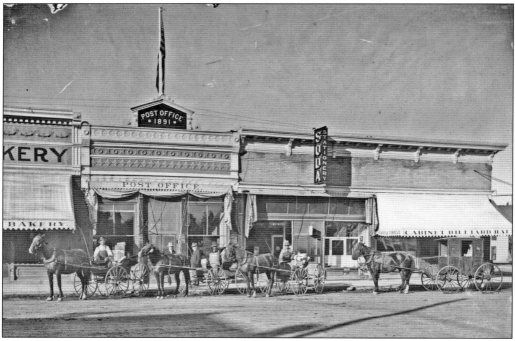

In 1891, the Montrose Post Office moved into larger quarters at 17 Cascade Avenue, closer to the street that would become North First. Movement of the mail to and from Montrose was contracted to carriers equipped with a horse and buckboard. A two-horse team pulling heavier loads and enclosed carriages protected the mail from the weather over longer and more difficult routes.

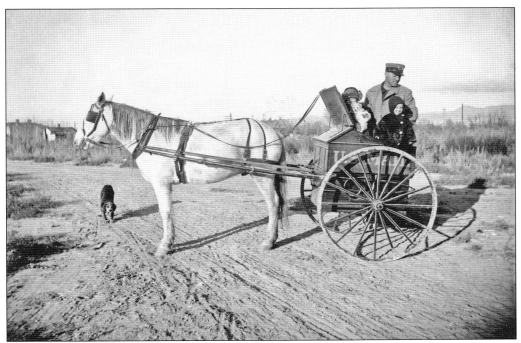

As the community grew, the postal service added horse-drawn delivery service. An interest in mail service and delivery was fostered young in this family; one of this mailman's children went on to join the postal service as an adult.

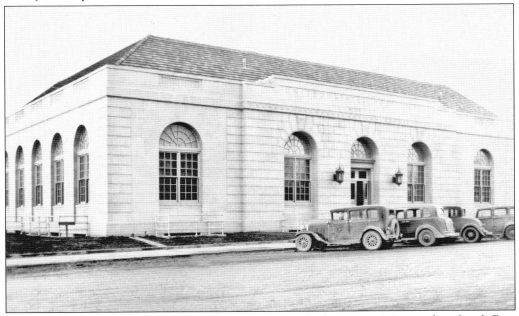

Construction of a new Montrose post office building took place in 1932. Located on South First Street across from the three-story stone courthouse, the site filled a full city block. The building was listed in the National Register of Historic Places in 1986. This building continues to function as Montrose's central post office.

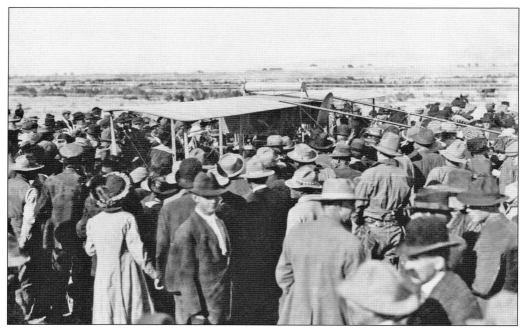

In 1913, the first airplane to land on the dirt strip west of Montrose was met with much excitement. Many crowded around to get a good look at the machine and to wonder at the evidence of progress. Air mail service, a dream of the local postmaster, was now possible.

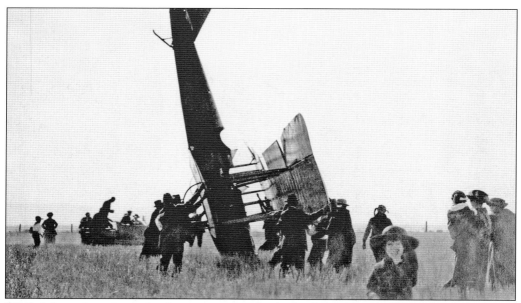

While Montrose was proud to have an airstrip for the landing and takeoff of early airplanes, the location of the airstrip on Sunset Mesa, just across the river west of town, was not such a good idea. Unpredictable crosswinds proved to be a serious hindrance, as this 1914 crash illustrated. The airstrip was soon relocated to level ground north of town. The airport grew along with the town, and today it is a regional transportation hub.

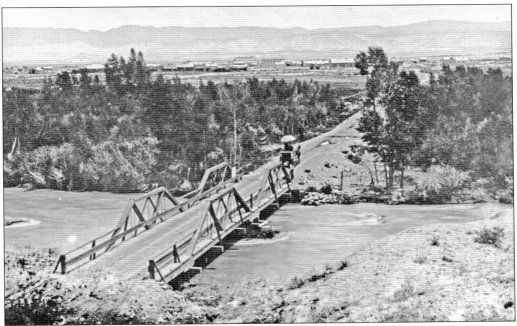

The wooden structure at the end of Main Street was the only bridge over the Uncompahgre River for many years. It was replaced with one made of iron in 1898. This river crossing was important as the route to travel west from Montrose. Traffic to any destinations south of Montrose also crossed the bridge, then turned left following behind Sunset Mesa, locally known as the "hogback."

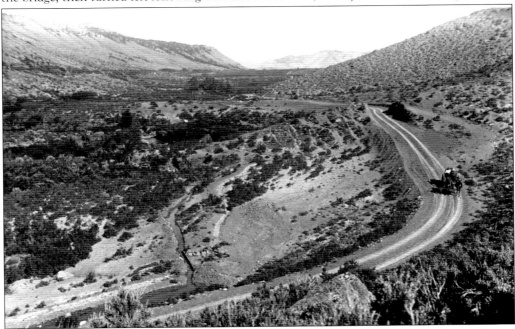

The "improved" road over Cero Summit was a steep dirt track through the brush and rocks. Conditions were dirty and rough when dry, becoming impassable when wet or snowy. Travel to Cimarron, while only about 15 miles away, took much of the day. No wonder train travel was preferred.

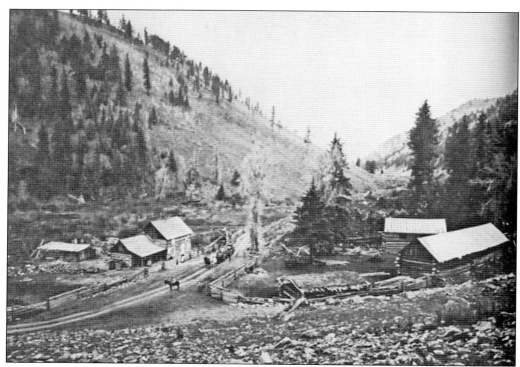

The road built by Dave Wood in the spring of 1884 was intended as a cutoff to save on travel from Montrose to Telluride. The previous road required traveling toward Ouray, then turning west over Dallas Divide on the Otto Mears Toll Road. Wood accused Mears of being too cheap to maintain the toll road. Wood's new road climbed west, turned south over Horsefly, and rejoined the existing road at Haskell's on Leopard Creek, saving about 15 miles. The Dave Wood Road is still an important local route.

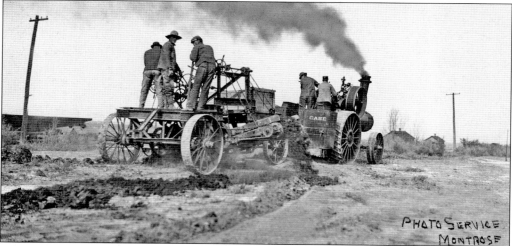

Old trails became roads as wagons traveled over them, but as the population increased, improvements were needed. Joint efforts by local communities expanded the road system until governments could be persuaded to take over further projects. By 1912, the introduction of steam-powered tractors to pull equipment had given road crews the advantage of machinery for construction.

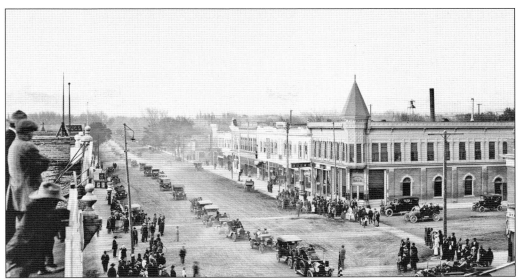

Roads were so important in western Colorado that the creation of one was celebrated with a parade. In 1914, the opening of a dirt but graded road between Montrose and Grand Junction was welcomed with a caravan of automobiles parading the 60-mile distance between the two towns.

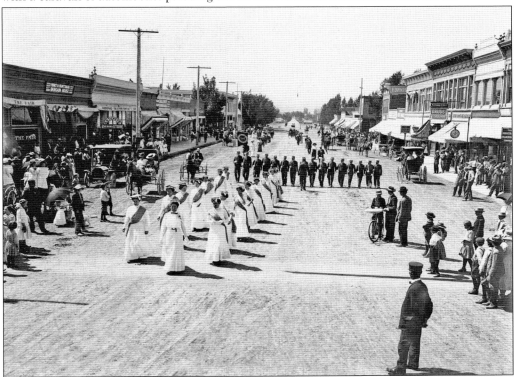

Citizens of Montrose have always loved parades. Parades have traditionally been held for the Fourth of July and the Montrose County Fair. In addition to established occasions, parades seem to spontaneously materialize for any and every reason, from Armistice Day to the winning of a high school ball game. Anytime a parade takes place, the town turns out in full support.

The popularity of the Montrose County Fair convinced the fair board to press for a pavilion to shelter the exhibitors and their displays. A large frame building was constructed with an open interior and dirt floors in the 1000 block of North Second Street to accommodate a diversity of exhibitors. Named Friendship Hall, it served as the center of fair activity for many years. In later years, a deteriorating Friendship Hall was replaced by a modern steel structure with cement floors that continues to serve as a community gathering place.

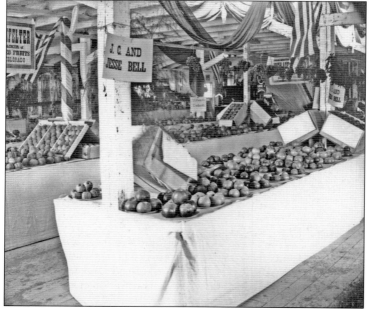

The Montrose County Fairgrounds exhibit hall was built of wooden frame construction and painted white. Tables provided display surfaces for fruits, vegetables, crops, and other farm produce. Exhibit spaces were reserved for presentations from individual communities to demonstrate the quality of their produce, handiwork, sewing, baked goods, and canned food. Competition between community groups was strong.

The Montrose County Fair has been a popular annual event from the first one held in 1884. In addition to livestock shows and judging, each rural community proudly displayed samples of their best crops and produce. With strong competition between exhibitors, a community's booth required days of careful preparation.

The Montrose County Fair was an opportunity for local merchants to display their wares for wider public inspection. Reeves and Mather operated a furniture store on Cascade Avenue, offering a line of quality household fittings and accessories. A well-displayed demonstration of appointments at the county fair was intended to attract the local housewife.

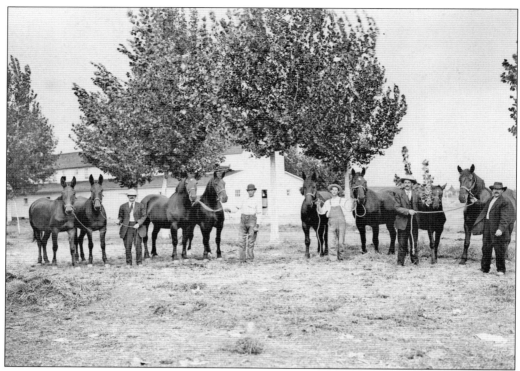

Horses provided power for transportation, farming, and pleasure, so owners were proud of their teams. Horse shows at the county fair were popular events, with entrants eager to display their animals for judging and the admiration of fair attendees.

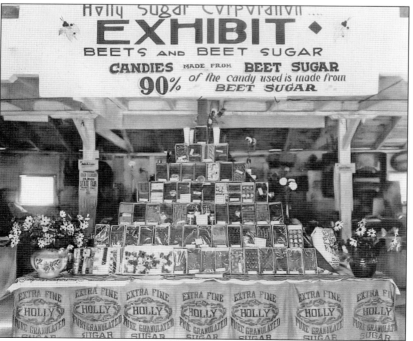

Commercial displays at the county fair provided an effective advertising outlet that was sure to be viewed by a majority of the local population. Holly Sugar was of major importance to the local economy from 1890 to 1976, supplying both a market for a product and many factory jobs.

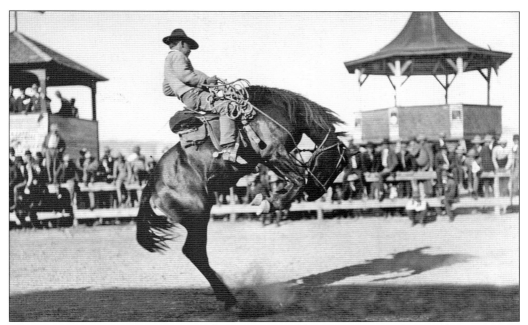

The Montrose County Fair was usually accompanied by an amateur rodeo and horse race. A popular event was the crowd-pleasing "Buckin' Bronc" competition. The rider was seldom able to stay seated for the necessary time to qualify for any of the prize money.

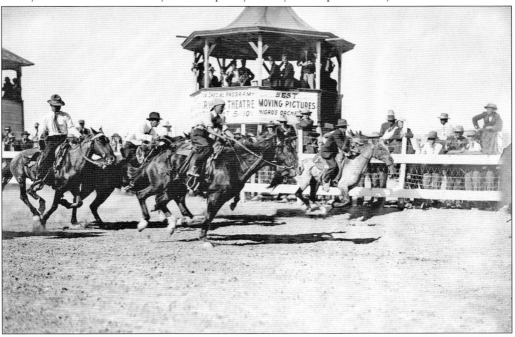

Horse races at the Montrose County Fair were usually a strictly amateur event. Anyone with a horse and high hopes lined up at the starting line. Mad dashes for the finish line had little in the way of style or technique, but everyone enjoyed the participation, including, one suspects, some of the cow ponies.

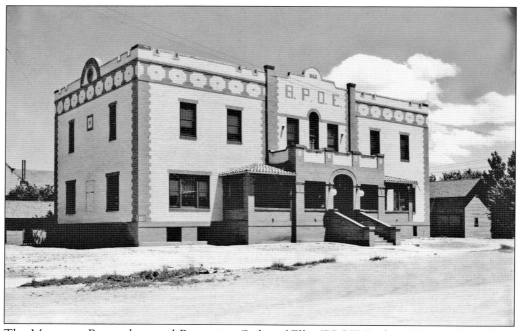

The Montrose Benevolent and Protective Order of Elks (BPOE) Lodge 1053 was formed on November 24, 1906, as an affiliate of the Ouray Lodge 492. They were required to be connected to the Ouray lodge until the Montrose population reached 5,000. The lodge hall, at South First Street and Cascade, was built in 1927 and has been listed in the National Register of Historic Places.

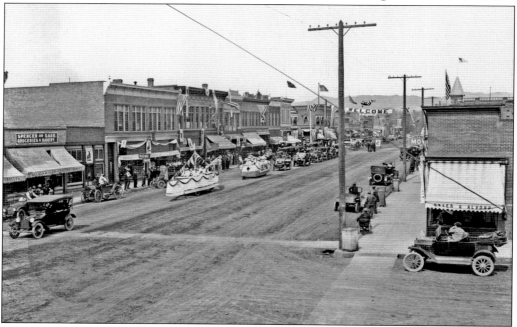

Montrose community members joined the Elks Lodge in welcoming convention guests with a parade down Main Street. Local Elks were determined to present Montrose and local Lodge 1053 as an involved and active organization, in spite of having been instituted as recently as 1906.

The Montrose Masonic Lodge No. 63 was granted a permanent charter on September 16, 1885. They outgrew their temporary quarters, so they contracted to use the second story of the building at 345 East Main Street. After 25 years in that location, lots were purchased in the 500 block of East Main Street, and in 1910, construction contracts were let for the new building. The lodge included commercial space on the ground floor, with Adams' Office Supply as tenants from the 1960s to the 1980s.

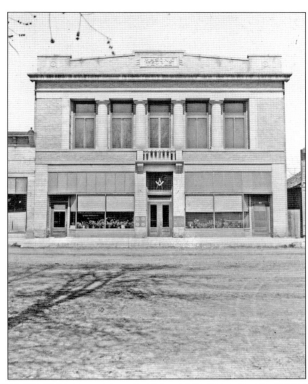

The Knights of Pythias Convention gathered in front of the lodge's building at 33 South Cascade Avenue in Montrose around 1920. Many men in the Montrose community were members of the fraternal organization, which pledged to "promote friendship and relieve suffering."

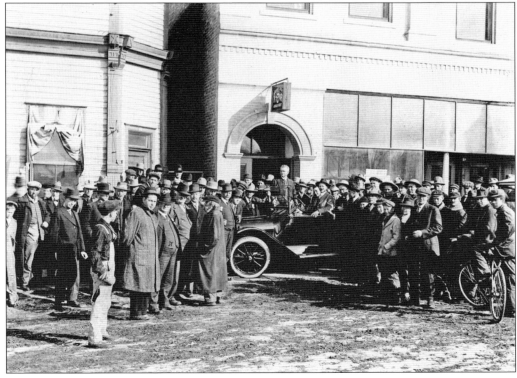

Montrose social clubs organized for many purposes. Some would observe special holidays as an opportunity to meet and enjoy an entertaining time together. Dressed to commemorate George Washington's birthday in 1916, the Reviewers Club met for the occasion and had their picture taken as a keepsake.

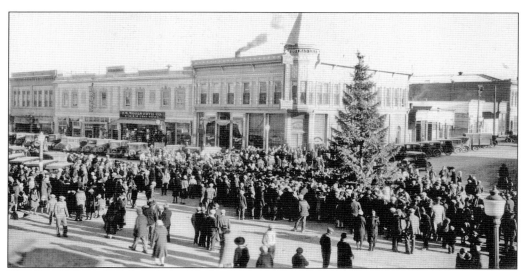

The Goodfellows were businessmen of Montrose who met yearly and contributed to a collection to fill bags with candy and nuts for local children to receive a special treat at Christmas. The Goodfellows Christmas Tree and Treats event was held on the corner of Main Street and Cascade Avenue in 1920. This treat was especially welcome during the Depression years.

The first church in Montrose was constructed in 1885 for the Methodist congregation, with contributions assisting the local efforts solicited from around the country. The brick structure was located on the corner of North First Street and Cascade Avenue. The pastor, Rev. William Osborn, built the parsonage at his own expense next door to the church. Condemned for safety reasons, a new Methodist church was constructed on the corner of Park Avenue and South First Street.

The second congregation to form was the Union Congregational Church of Montrose, established by Rev. R.T. Cross and Thomas Marsh on Sunday, August 2, 1885. The necessary articles were drawn up, and a committee was named to find lots for a building site. By August 15, a location on the corner of South Third Street and Townsend Avenue had been selected. That church burned in 1917, so the congregation built a new stone church on the southwest corner of South First Street and Uncompahgre Avenue.

Organized in 1891, the 1900 Baptist congregation met in a small frame church on South First Street. The building was conceded in 1922 to provide a central location for the construction of a new Montrose County Courthouse. The church moved to the corner of South Third Street and Townsend Avenue, the previous site of the Union Congregational Church. This site functioned as the location of the Baptist Church for decades to follow.

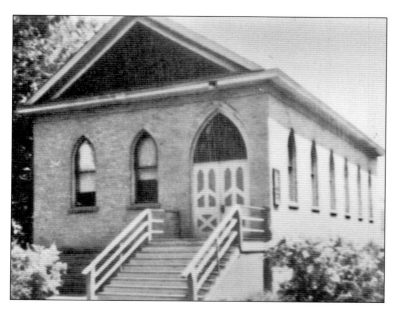

The Montrose United Presbyterian Church was organized in 1909, and a new sanctuary was dedicated in 1910. In 1918, Rev. Mark Warner began his long service to the Presbyterians and to the Montrose community. Reverend Warner was active in efforts to acquire the 1933 National Monument status for the Black Canyon. A lookout at the Black Canyon is named Warner Point in his honor.

Bibliography

Butler, Waldo, and P. David Smith. *Mountain Mysteries: The Ouray Odyssey.* Ouray, CO: Ouray Chamber of Commerce, 1981.

Clark, David, and Wm. Joe Simonds, ed. *Uncompahgre Project.* Bureau of Reclamation, 1994.

Freeman, Donna, ed. *100 Years: Montrose, Colorado.* Montrose, CO: Montrose Daily Press, 1982.

Galloway, Alva W. *Passing of the Two Gun Era.* Montrose, CO: Montrose Daily Press, 1940.

Greater Montrose Centennial Inc. *Montrose, Colorado, Centennial: 1882–1982.* Grand Junction, CO: Great Western Printing and Binding Inc., 1982.

Jocknick, Sidney. *Early Days on the Western Slope of Colorado.* Glorieta, NM: The Rio Grande Press Inc., 1968.

Monroe, Arthur W. *San Juan Silver.* Montrose, CO: Montrose Press, 1940.

Nankivell, Maj. John H. "Fort Crawford, Colorado: 1880–1890." *Colorado Magazine* XI: 54–64.

Rockwell, Wilson. *Uncompahgre Country.* Denver, CO: Sage Books, 1965.

Selig, Hugo. *Early Recollections.* Montrose, CO: Montrose Daily Press, 1939.

Woods, Frances, and Dorothy Woods. *I Hauled These Mountains in Here.* Caldwell, ID: Claxton Printers Ltd., 1977.

Discover Thousands of Local History Books
Featuring Millions of Vintage Images

Arcadia Publishing, the leading local history publisher in the United States, is committed to making history accessible and meaningful through publishing books that celebrate and preserve the heritage of America's people and places.

Find more books like this at
www.arcadiapublishing.com

Search for your hometown history, your old stomping grounds, and even your favorite sports team.

Consistent with our mission to preserve history on a local level, this book was printed in South Carolina on American-made paper and manufactured entirely in the United States. Products carrying the accredited Forest Stewardship Council (FSC) label are printed on 100 percent FSC-certified paper.